Edward Burra

JOHN ROTHENSTEIN

Edward Burra

THE TATE GALLERY

ISBN 0 900874 60 0 Paper 0 900874 61 9 Cloth

Published by order of the Trustees 1973
Copyright © 1973 The Tate Gallery
Designed and published by the Tate Gallery Publications Department,
Millbank, London S W 1 P 4 R G
and printed in Great Britain by Balding & Mansell Ltd, Wisbech, Cambs.

Contents

7 Foreword *Norman Reid*

8 Acknowledgements

9 List of Lenders

11 Edward Burra *John Rothenstein*

37 The Plates

85 Letters and Postcards

93 Catalogue

Cover
Elephant Lady, 1954

Frontispiece
Edward Burra photographed by C. Thewenet

Foreword

Edward Burra stands a little aside from the mainstream of modern art over the last 45 years, although his work shows him to be by no means unaware of that of his contemporaries and intensely aware of people, places and things which he examines with a retentive eye.

His painting is vividly idiosyncratic and memorable; it projects his fantasy with a degree of conviction powerful enough to create a rival reality disturbing and infectious to one's own.

The present exhibition is the first large retrospective of Edward Burra's work chosen from a period of some 50 years.

I am particularly happy that my predecessor, Sir John Rothenstein, who wrote the first, small book on Edward Burra as long as 28 years ago, accepted my invitation to select the exhibition and write the introduction to the artist's work in this book.

We are, as is so often the case, deeply indebted to the artist and to all the lenders to the exhibition, especially to Messrs Reid and Lefevre, the artist's agents who have been exceptionally helpful with loans and information.

Mrs Barbara Ker-Seymer and Mr William Chappell have shown us great numbers of Edward Burra's amusing letters and postcards and have been kind enough to permit us to print excerpts.

Norman Reid

Acknowledgements

I should like to offer my warmest thanks to Sir Norman Reid and the Trustees of the Tate Gallery for giving me the opportunity of selecting the works for this exhibition and of writing the introduction of the catalogue; to Mr Michael Compton and Miss Ruth Rattenbury for their invaluable help throughout, and to the Lefevre Gallery for information as to the whereabouts of many exhibits without which it would have been impossible to trace them, for the provision of photographs and for help of other kinds.

For biographical and other information I am greatly indebted to Mr Richard Buckle, Mr William Chappell, Mrs Beatrice Dawson, Mrs Barbara Ker-Seymer, the Leicester and Mayor Galleries, Mr Barrie Penrose, to the artist's sister the Hon. Mrs Colin Ritchie, and to Edward Burra himself. Mr Conrad Aiken has also been very kind in allowing me to quote from a letter to Paul Nash.

I would also like to offer my thanks to the other members of the Tate Gallery staff who have worked to realise the exhibition and to design and produce the catalogue.

J.R.

List of Lenders

Penelope Allen 19
Dame Cicily Andrews 133
Arts Council of Great Britain 72, 116
J.G. Aspinall 103

Michael Benthall 90
Mr and Mrs Cecil Bernstein 132
Mrs Gordon Binnie 131
Mr and Mrs Jean-Jacques Boissier 81
British Museum 94
British Petroleum Company Ltd 107

William Chappell 7, 54
Desmond L. Corcoran 47, 48, 50, 87
Mrs Desmond Corcoran 13, 106, 123
J.F. Cullis 10, 32
The Rt Hon Lord and Lady Craigmyle 135

Beatrice Dawson 35, 36
Mr and Mrs John Deen 114
Miss M.A. Du Cane 45
University of Dundee 88
Ian Dunlop 86

D.W.E. Eckart 46, 84

Sir Frederick Gibberd 67
Conrad Goulden 124
Helen Grigg 23

Hamet Gallery 17, 76
Sir Robert Helpmann 59
Cecil Higgins Art Gallery 80
Sir Antony Hornby 113

Joseph Janni 115
Mr and Mrs Nicholas Jones 3

Barbara Ker-Seymer 12, 27, 30, 31
Max Ker-Seymer 136
The Lord Killanin 61
Kuhn, Loeb & Co. International 53

Lefevre Gallery 18, 25, 64, 65, 70, 71,
 74, 75, 78, 82, 83, 85, 89, 91, 93, 95, 96,
 99, 109, 110, 117, 122, 125, 126, 137,
 138, 139
Edward Lydall 57

Mrs Gerald MacCarthy 16
Sir John and Lady Macleod 120
George Melly 121

J. O'Brien 98
Anthony d'Offay 29

Mr and Mrs A.D. Pilcher 38
Anthea Pooley 37

Private Collections 4, 9, 11, 14, 15, 21, 22, 24,
 26, 33, 34, 40, 42, 49, 51, 55, 56, 69, 77, 79,
 97, 100, 104, 105, 108, 111, 127, 128, 129,
 134, 140, 142, 143

The Hon. Mrs Colin Ritchie 1, 2, 102
A.F. Roger 60, 101, 130
Sir John Rothenstein 20, 39, 52

John Schlesinger 8
Scottish National Gallery of Modern Art 63

S. Martin Summers 5

Tate Gallery 28, 41, 43, 62, 68, 73, 92
J. Walter Thompson (London) 119

Mark A. Vaughan-Lee 44
Vickers Limited 112
Douglas Villiers 141

The Lord and Lady Walston 6, 58, 66
V.G. White 118

JOHN ROTHENSTEIN

Edward Burra

In his fourteenth year Burra's prospects for the successful pursuit of any vocation must have seemed negligible; even indeed, his fitness for any vocation at all could readily have been called in question. Never robust he was subject to a combined attack of anaemia and rheumatic fever of such severity that he has never fully recovered from its consequences. At the age of thirteen his constitution was gravely impaired and he was compelled to leave school with minimal education. (I once referred to his uncertain health, and he replied 'Nonsense: I have the constitution of a mule; otherwise how could I have made it for so *long?*')

These seemingly catastrophic circumstances combined, however, to enable him to become an artist. Unfit to prepare for a regular profession, he became free to devote his acute and original mind, his almost prematurely penetrating observation, and his entire time, to his chosen vocation. He was spared the accumulation of knowledge irrelevant to an artist; and moreover his parents, and not only on account of their anxiety about his health, welcomed an interest in the arts and fostered his adoption of the vocation of his choice however uncertain the prospects it offered.

The artists of the past owed much of their technical resource to prolonged apprenticeship. At the age when the students of today begin their education, their early predecessors had at least mastered the elements of their art and often considerably more. In this respect Burra resembled them, for from the age of fourteen he was able to draw, paint, observe and enlarge his imaginative experience without opposition or distraction. The continuing precariousness of his health has required him to dedicate all his energies to the pursuit

of his art; he has little superabundance for conventional pleasures and none for the politics of art. Even his personal relations are of a special kind: he feels, I believe, particular affection for and even dependence on his small circle of old friends, but it is almost invariably they who must take the initiative when meetings are concerned. Were they to fail to do so, friendship would languish. But they do not fail, and he is warmly responsive. 'I have been meaning to write but never have of course' is a sentence that recurs in his letters. When he writes he writes very fluently, though the premature ending of his formal education is evident in the casualness of his spelling: Herbert Read is 'Herbert Reed', foreigners are 'foriegners' and so on, and his handwriting, although not so childlike as Lucian Freud's, can have developed little since his schooldays. His letters reveal at times the same characteristics as his paintings, a preoccupation with the macabre and, particularly in the earlier, with the shoddy.

As a man he seems to suffer from a languor, even an exhaustion, so acute as to suggest that he is incapable of action of any kind. Incapable in fact of standing for long periods he said to me 'I must sit down most of the time; if I could work lying down I'd do so.' Even in his student days he put me in mind of an inactive, almost run-down being, so near to exhaustion did his reserves of energy seem. There was little about Burra's presence to suggest that he was shortly to show himself to be an artist of astonishing originality, and to be the creator, over some fifty years, of a long series of highly finished paintings.

Edward John Burra is the eldest child but one (who died young) of Henry Curteis Burra, JP, active in the public life of Rye, Sussex, living at nearby Springfield—and his wife Ermentrude Anne, born Robertson Luxford. Edward has a sister Anne, with whom his relations have remained very close, who is married to the Hon. Colin Ritchie and lives near Rye. He was born on 29 March 1905 at his grandmother's town house, 31 Elvaston Place, South Kensington. The school which he had to leave prematurely on account of the collapse of his health was Northaw Place, Potters Bar. 'There were a great many strange scholars there,' he said,

describing the school, and manifesting his preoccupation, even as a boy, with the quality of strangeness of which he was later to give such masterly expression.

After leaving Northaw Place he drew and painted at home in Rye until 1921, when he spent two years at the Chelsea Polytechnic.

At Chelsea he became friends with the future theatrical director, William Chappell; the fact that they were younger than most of the other students first brought them together, but this friendship—as with others formed in his early years—has flourished until today. Chappell remembers Burra's addiction to squalid subjects with sinister overtones. Looking at some of his drawings of hags screaming at each other in Casey's Court, a slum street, one of the masters asked him why, for a change, he didn't draw some smart people. He did so, and the smart people looked more frightful than the hags. In 1923 he transferred to the Royal College of Art, remaining there for a year.

At the College, where I first became acquainted with him, he was regarded as something of a strange scholar himself, partly on account of occasional eccentricities, but far more for his extraordinary sophistication. The life drawings he made there show that he was already an extremely accomplished draughtsman. During years when his fellow students had been applying their attention listlessly to *The Aenead* or the binomial theorem—subjects with little relevance or none at all to the nourishment of artistic talent—Burra had been charging his imagination with precisely the ideas and the imagery that it most required. With the literature, for instance, of the cosmopolitan world centred in Montparnasse, Blaise Cendrars, Francis Carco, Pierre Macorlan and Daniel Fuchs. But he was also widely read in earlier writers, in particular the Elizabethans Tourneur and Marston, whose *Scourge of Villainie* was a favourite, as well as Walpole's *Castle of Otranto* and Harrison Ainsworth's *Tower of London*. With *Oliver Twist*, too, he was familiar. Although such works treat of a wide variety of subjects, they do—with the exception of Dickens—offer an indication of the two that obsessively preoccupied him and accordingly contributed to the enhancement of his creative energy and to the sense of

purpose which young artists are often slow to discover.

These two subjects were the Latin South, especially its underworld, and the sinister and menacing aspects of life in general. 'I've never been even faintly curious about any northern country, but I've wanted, for as long as I can remember, to go to Mexico and Venice,' I heard him declare. In later life, however, he has become attracted by the north of England, especially Yorkshire, also by Ireland. About his representation of evil there is a quality that distinguishes him from the satirist, from, for example, George Grosz, whose work he particularly admires. Grosz exposes, with grim ridicule, the brutish callousness and greed, the arrogance and capacity for hatred of his early German profiteer type of subject. Burra creates manifestations of evil of various kinds, but without ridicule or censure. Burra's evil is shown simply as evil, without comment. Since the artist will be personally unknown to the large majority of readers of this description of him, it is only just to make clear that his depiction of evil is not in any way an expression of his own character—far from it. It is simply that evil—which he regards with an obsessive horror tinged with amusement—happens to be the particular aspect of life to which his attention is habitually drawn.

It was characteristic of Burra that he did not wait until he visited the continent to portray with a profusion of detail the various aspects of its low-life that was to be his chosen theme for some fifteen years.

By the time of his arrival at the Royal College of Art Burra's knowledge of paintings was as wide as it was of literature. Caran d'Ache and Doré were early favourites, but El Greco, Zurbaran, and in particular Goya were more enduring influences. From Signorelli he learnt the effectiveness of hard, simple modelling and of the taut pose for conveying suggestions of restrained violence. Among other contemporaries and near contemporaries those he studied to most purpose, were besides Grosz, Beardsley, Dulac, Walter Crane, Chirico, Wyndham Lewis, Dali and the now all but forgotten Covarrubias. As the number and variousness of the artists suggest, Burra was the disciple of none, but like a magpie picked up what he fancied. But what he took he assimilated into an

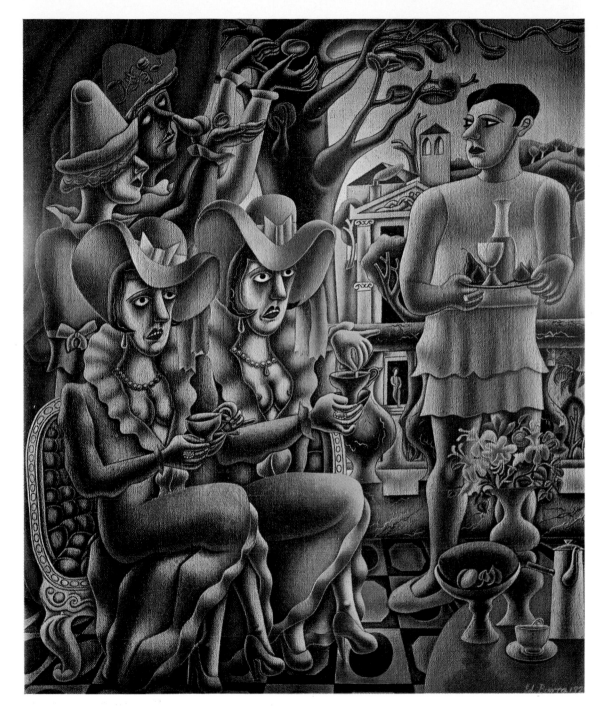

4 THE TWO
SISTERS, 1929
Oil, $23\frac{1}{2} \times 19\frac{1}{2}$
(60×49.5)
Private
Collection

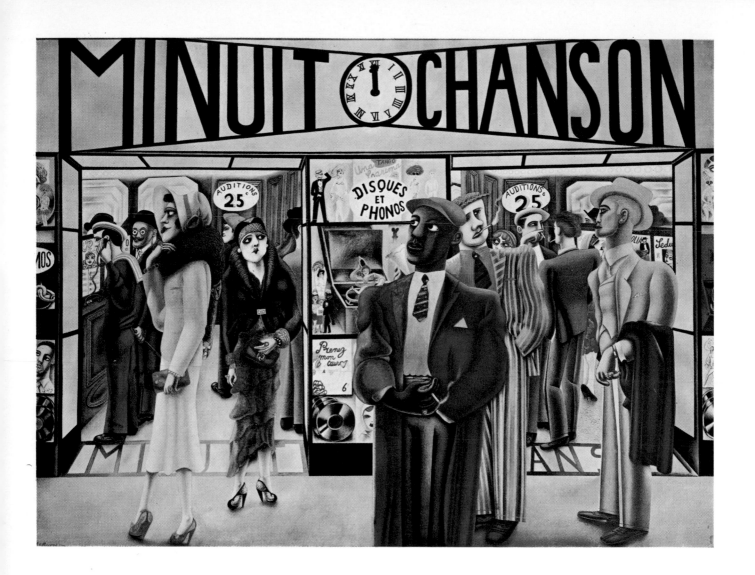

31 MINUIT CHANSON, 1931
Watercolour, 21½ × 29 (54.5 × 73.5)
Barbara Ker-Seymer

art that had become, by his mid-twenties, one not remotely resembling that of anyone else: lucid, audacious, fantastic, and conveying often overtones of menace and corruption.

There was something bizarre in the contrast between the delicate young man who, though at times 'a strange scholar', was home-loving, and the products of his imagination: nocturnal encounters in the red-light districts of continental cities, scenes set in the water-side cafés and sailors' brothels of Mediterranean ports. These places were represented with meticulous correctness, for Burra was not only acquainted with picaresque literature in more than one language but, like Utrillo he made extensive use of picture postcards.

From the middle 'twenties, when he made fairly frequent visits to the continent, his use of postcards diminished, and he came to rely increasingly on his extraordinary memory—a memory so precisely retentive that he has no need even to make sketches and he returns from tours or expeditions to possible subjects with his mind charged with a wide range of images exactly envisaged. When he is driven in a car he appears to look at nothing in particular; just to stare straight ahead.

Not long after leaving the College, he and Chappell, 'chaperoned' by the Henry Rushburys, visited Paris. A year or so later the two of them spent some time in Cassis, a town that delighted him; also, with several other friends, Toulon. One of them, Beatrice Dawson, remembers that when the others enjoyed themselves on the beach (where he was never seen) he sat in a back room of the hotel, painting and eating ice-cream. A fountain in Toulon he later adapted for the drop-curtain in his setting for the ballet *Rio Grande*. He was seen off by another group of his friends, who noticed that his luggage consisted of no more than one small suitcase containing some papers and a spare pair of trousers.

Allusion has been made to his friends. Between him and them a very special relationship subsists. Burra is a friendly person, ready for instance to strike up an acquaintance with someone met by chance in, say, a pub, but his intimates are mostly among those who were fellow students at the Chelsea Polytechnic or the Royal College of Art (and in one or two instances, both). These are

William Chappell, Beatrice Dawson, Barbara Ker-Seymer and Frederick Ashton. Three others, now dead, were John Banting, Basil Taylor and Georgiana Hodgkins. They were drawn together by a common interest in films and ballet, as well as painting. Unlike so many student friendships, they have not only survived but grown closer. The chief friend of a later date is Gerald Corcoran (formerly married to Beatrice Dawson), director of the Lefevre Gallery, where he has shown for many years. On his fortnightly visits to London he stays with one or other of them, and their spare bedroom is often alluded to as 'Edward's Room'.

In 1930 he made a journey through France under the guidance of Paul Nash which took him again to visit a number of his favourite subjects, sailors' bars and the like.

Apart from his three student years he has lived all his life in Rye, which provides a small, although of late years a slightly increasing, proportion of his repertory of subjects. Travel, however, is a necessity to him, both as a spur to his imagination and as a means of extending this repertory. Besides the continent he has visited the United States and Mexico, where he became seriously ill, and going to Boston, spent weeks recovering in a basement room. Although his health requires that he preserve almost all his energies for his art, in life he occasionally behaves like one of his own creations. 'Which reminds me somehow' Paul Nash wrote to a friend in the summer of 1934 'of a lovely story [Conrad Aiken] told me of Ed's arrival in New York. Conrad met him at the Customs displaying the most awful mess of Woolworth underwear mixed up with paints and French and Spanish novelettes which was passed by the customs officer, an enormous Irish Yank. But as Ed stooped to close up his bag a large bulge in his hip pocket betrayed a considerable bottle of whisky. The officer leaned over and without a word tapped the bottle with a pencil. Conrad began to feel anxious and I'm sure did a lot of scratching behind his ear. But Ed didn't even straighten up, he leered round at the cop and said in that withering voice of his *"it's a growth."* Conrad said the chap was completely broken, he just got very red and wandered away looking at other things.'†

†Anthony Bertram, Paul Nash 1955, p.221

In any case, Burra did not allow his precarious health to inhibit entirely his innate disposition to pursue, although fitfully, an independent way of life. There was a story current among his friends that one afternoon he walked out without a word. When night came he had not come in, nor was there any sign of him for some three months. One evening he strolled back casually though thin as a skeleton. It transpired that he had been to Mexico and lived in New York, making drawings and watercolours of Negro life in Harlem. When I questioned him he admitted that the story was not entirely apocryphal. It related, probably, to the expedition of 1933–4. One of these watercolours dated 1934 and entitled 'Harlem' was bought five years later by the Tate.

Unlike those of most artists of the present century, Burra's style has changed little: the clearly outlined, suavely modelled forms, usually near the paper's surface, the minutely observed detail, the absence of atmosphere ('I don't believe I *see* atmosphere' he said to me) have all remained virtually unchanged. Later in his life, when he painted landscape observed rather than imagined, English and Irish weather being what it is, he had to 'see' atmosphere, but even in such an outstanding example as 'Low Tide, Rye', of 1963, although mist-covered mud flats are represented, the artist's primary interest was focused on the eerie formation of the trees in the foreground, leafless, almost twigless, and the way they relate to the chilly unruffled surface of the sea. The atmosphere is scarcely more than a backdrop, rather than something to be represented more, as it would have been by Turner, Constable or an Impressionist, for its own sake. 'Indistinctness is my forte,' as Turner is supposed to have said: Burra's forte is the near, the sharply defined, the minutely observed yet represented in terms of large, audacious and unexpected form. But if his style has evolved little, the informing spirit has undergone two changes, one of them radical.

From his student years until the middle 'thirties his principal preoccupation remained the low life of the Mediterranean port, the sailors' café or brothel, exemplified by such works as 'Rossi' of 1930, showing a French sailor eating by himself in a café with eight white, red pom-pommed caps so disposed upon a hat-rack like strange, delicate insects, contrasting with the huge Rossi bottle in the fore-

ground or 'The Café' of 1932, in which a young man sits in slyly smiling meditation upon some unlawful pleasure or nefarious plot, the foreground dominated not by a bottle, but by his companion's huge cloth cap. One feature of his art of those years was preoccupation with the cheap. What other artist has caught so inexorably the exuberant cut and the fibrous texture of cheap clothes? In rather the same way as Francis Bacon, a member of an 'old' family is disposed to magnify the good qualities of proletarians, Burra, brought up in prosperous upper middle class surroundings, was fascinated by the meretricious. Although he looks occasionally through *The Times*, the 'popular' newspapers are his preferred reading, from which, however, he manages to be extremely well informed about the major issues confronting the world, as well as many comic and bizarre happenings that would elude an exclusive reader of *The Times*. I refer to this fascination in the past tense because it diminished as a consequence of the radical change that affected his art from the middle 'thirties—a change reflected in a gravity of outlook rarely perceptible before. The change was, however, not instantaneous. It is anticipated for instance in the sinister and enigmatic 'John Deth' of 1932, surely among his finest pictures. In it is portrayed the scythe-bearing figure of death intruding upon a party of dancers, striking the guests with terror, which sometimes expresses itself with tragic absurdity, as in the expression of the coarse-featured man wearing a paper hat who, in the act of embracing a woman, suddenly perceives Death kissing another woman paralysed by fear.

'Original' is a term apt to be too comprehensively applied, but it perfectly fits 'John Deth'. However the radical change, in part temperamental and in part, perhaps predominantly, due to the ubiquitous signs of imminent catastrophe, came a few years later. The assumption of power by the nazis warned the world—although many were long reluctant to face the issue—that people must submit to a slavery of the most degraded character and to arbitrary massacre or else must fight for their liberty, or even their survival. The issue was brought into sharper focus by the Civil War in Spain. This terrible event seized the imagination of a world unable to foresee the far greater catastrophies immediately ahead.

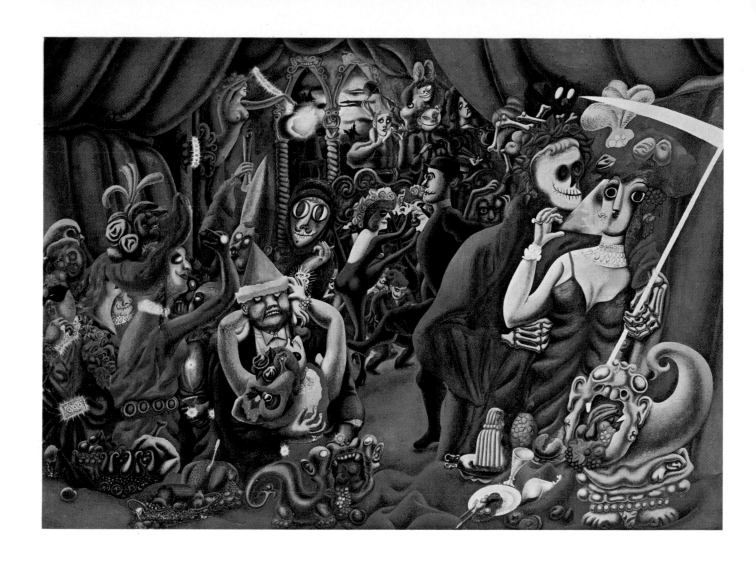

33 JOHN DETH, 1932
 Watercolour, 22 × 30 (55.9 × 76.2)
 Private Collection

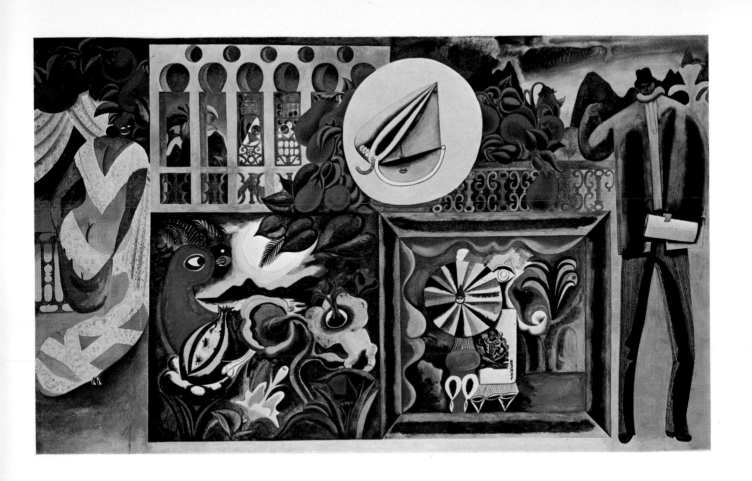

51 COMPOSITION, 1935
Watercolour, 20 × 33½ (51 × 85)
Private Collection

Just before the beginning of the Spanish War Burra happened to be in Madrid. 'One day when I was lunching with some Spanish friends,' he told me, 'smoke kept blowing by the restaurant window. I asked where it came from. "Oh, it's nothing," someone answered with a gesture of impatience, "it's only a church being burnt." That made me feel sick. It was terrifying: constant strikes, churches on fire, and pent-up hatred everywhere. Everybody knew that something appalling was about to happen.'

Burra has spoken to me on several occasions of the Spanish Civil War, but he has given little indication of partisanship. To him the all-pervasive element of tragedy seems to preclude it: he was over-whelmed by the cruelty, destruction, hatred and death. It was a tragedy in which all concerned, however culpable, were in the last analysis victims. I say little indication of partisanship rather than none at all because horror at the burning of churches inclined him to identify the Franco party with civic stability, but I never heard him express even the most oblique approval of fascist ideas.

The war had for Burra a special significance as an artist as well as a man. For several years before he had been under the spell of Spanish civilisation and had studied, with intense excitement, the great Spanish painters, as well as the luxuriantly dramatic (and in England then little known) architecture and sculpture of the Jesuit-commissioned baroque churches of Mexico. He could also be stirred to enthusiasm by lesser artists. 'Have you heard of a Spanish painter Gutierrez-Solana?' he asked me in a letter of 11 October 1942, 'they are very remarkable, but not "well known" as Spaniards are not so good at advertising themselves as the French.' He taught himself Spanish (by the Hugo method), which he reads with ease, also French, though he is reluctant to speak it.

No artist personally known to me has led a more sequestered life. Although he has held one-man exhibitions fairly regularly, he finds them an ordeal: 'they make me quite ill' he wrote to me. On five occasions, however, work in a different medium brought him before a larger public than was aware of his paintings, namely designs for four ballets and an opera. These were 'Rio Grande', the music by Constant Lambert and choreography by Frederick Ashton,

in which Markova and Lopokova performed, produced by the Carmago Society in 1931; 'Barabau' (originally produced by Diaghilev with settings by Utrillo and choreography by Balanchine) produced by Ninette de Valois and performed by the Sadler's Wells Company in 1936; 'The Miracle in the Gorbals' performed by the same company in 1944; 'Carmen' in 1947 and the following year 'Don Juan', the music by Richard Strauss and the choreography by Ashton. The last two were performed at Covent Garden.

I myself saw none of these and know only a few of their settings from photographs, and designs, but in the issue of *Ballet and Opera* for January 1949 Richard Buckle, under the pseudonym 'Dorothy Crossley' paid him his tribute. 'In our century it was Diaghilev who first persuaded "easel painters" to work for the stage. He employed the greatest artists of the School of Paris. In England the Sadler's Wells Ballet and now Covent Garden Opera have wisely enlisted artists outside the ranks of the small band of the accepted theatrical decorators. Of these perhaps Burra has been the most successful and shown most feeling for the stage.' In the same article he wrote that his front curtain for 'The Miracle in the Gorbals' representing 'The prow of a great half built liner in the Dockyards, was grandly conceived', and of his costumes as 'cunning simplifications of contemporary cheap clothes to be seen in the backstreets of any industrial town.'

These performances brought him into favourable public notice, but after each one he disappeared from view.

In spite of his dislike for showing his work, it has been exhibited regularly, at the Leicester Galleries in 1929, 1932, 1947, 1949, at the Redfern in 1942, at the Hamet Gallery in 1970 and 1971, at the Postan Gallery in 1972, at the Lefevre in 1952, and there from 1955 biennially. 'I am a biennial,' said Ivy Compton-Burnett of her production of books, and Burra might say the same with reference to his exhibitions over the past sixteen years. These were received with respect and on occasion with wholehearted admiration, but until quite recently Burra has not been favoured by the establishment, never accorded, for instance, an officially sponsored exhibition, by the Arts Council, the British Council, even the Whitechapel, whose former Director, Bryan Robertson, is an ardent

admirer, or, until now, the Tate (although the Trustees did purchase seven of the eight examples of his work the Gallery possesses). Not that he has ever lacked admirers: Paul Nash—a close friend—and Wyndham Lewis both told me that they considered him to be one of the finest living painters. And his work sells sufficiently well to enable him to live in modest comfort.

I do not know whether others share my sense of shame at the discovery of their ignorance about aspects of the lives of friends whom they suppose they know well, and of acquaintances when significant circumstances about them—tragedies, interests, achievements and other crucial matters—are revealed in their obituaries, or in tributes when they are the recipients of honours or other distinctions—or most acutely when one has occasion to write about them.

This I felt when Kenneth Clark, aware of my particular admiration for Burra, invited me, in 1942, to contribute the small volume on his work in the *Penguin Modern Painters* series of which he was editor. This undertaking involved a closer association with Burra, bringing a wider knowledge of his art and character.

My first visit to Springfield, the Burra house in Rye, was an occasion I shall not forget. The house itself is wide-eaved, William IV or early Victorian. Its four-square solidity, the tweed coats and caps hanging in the hall, fishing tackle, shotguns and the like, reflected a certain conventionality, no less than that of Edward's father, a widely read and cultivated man who encouraged his young children to look at Caran d'Ache and Doré. He greeted me in formal but friendly fashion, and took me for a stroll round the garden. When I had climbed the stairs, adorned mostly by Victorian watercolours, to Edward's studio the contrast was startling—a contrast resoundingly proclaimed by a framed close-up photograph of a face far gone in leprosy. In a book devoted to Unit One, the distinguished but shortlived association of artists gathered in 1933 by Paul Nash (the only group, I believe, that Burra has ever belonged to), there are photographs of the studios of its members. That of Burra's suggests that it was tidy and bare. The book was published the following year but I do not know when the photograph was taken. No room could have been more unlike it than the studio I visited eight years later.

Photographs were pinned up covering the walls almost completely, of paintings by Tiepolo (one of the artists he most admires, but of whom I see no reflection in his work), Signorelli, Magnasco, a wide variety of Spanish masters, pictures clipped from popular newspapers and periodicals, mostly representing dramatic incidents, often with figures in violent motion. Covering his gramophone, wireless, chairs and areas of the floor, were hundreds of books, newspapers and periodicals, novels in English, Spanish, French and Italian, glossy South American picture magazines, Victorian scrap-books. And scattered among them scores of gramophone records, for he listens to music while he works, Berlioz being his favourite composer. (Beneath a similar profusion in nearby Springfield Cottage to which he eventually moved were discovered, in 1971, five wood-blocks, engraved in 1928–9, but never pulled and long forgotten by him and unknown to his friends. Their discoverer was the journalist, Barrie Penrose; the blocks themselves now belong to the Tate.) Constituting a top layer above this profuson were scattered long, white paper cylinders: his own drawings and water-colours, curled up (owing to his feeble health he prefers water-colour, as exacting less physical effort, to oil paint, which he has rarely used since the 'twenties). None of his own works were hung, but a few, returned from exhibition, leaned framed against the walls. A small work table stood close to a window, the light falling from the left. 'There never seems to be light enough,' he complained, 'and I can't work by electric light.' Since the installation of a 'daylight strip' at Springfield Cottage some years ago he has been able to work at any time of night. I recall this complaint because another visitor described a sheet hung from a corner of the window frame to protect him from the afternoon sun and to shut out the view of Rye. I saw none but ordinary curtains but whether the observation about the sheet is accurate or not the reference to shutting out the view of Rye has relevance. Burra has spent almost all his life there (in three different houses) and lives there to this day, but it has never engaged his affection; indeed indifference has sharpened into positive dislike for what he sometimes calls 'Tinker-bell Town'. It is curious, considering he could afford to live elsewhere, that he should not have left it. Lowry has no deep general

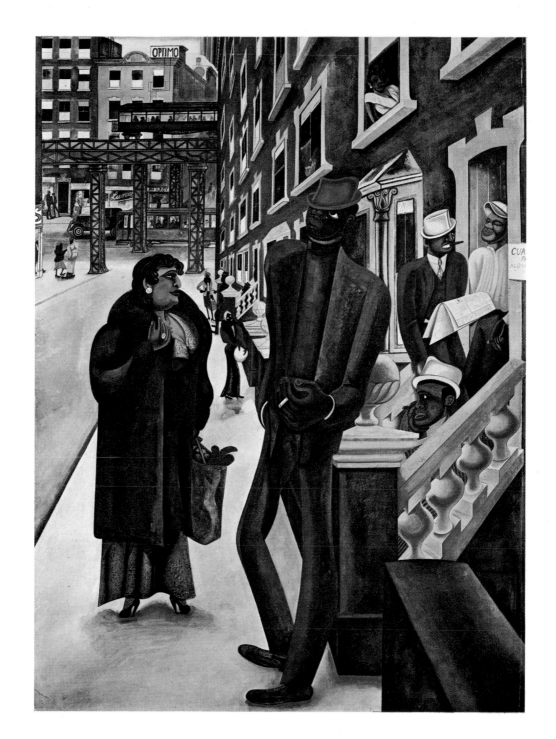

43 HARLEM, 1934
Watercolour, 31 × 22
(79 × 56)
Tate Gallery

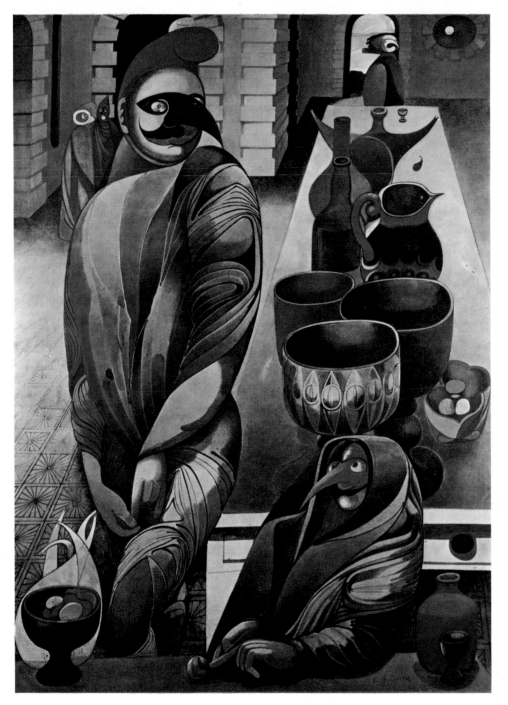

78 BIRDMEN AND POTS,
1947
Watercolour, $31\frac{1}{2} \times 22\frac{3}{4}$
(80×57.8)
Lefevre Gallery

sentiment for the Salford area, only for certain streets of poor houses, Oldham Road and other areas immediately adjacent to it, from which he draws the essential nourishment for his art, and needs accordingly to remain nearby. Althouth he has occasionally talked of leaving South Lancashire, I do not believe he ever will, or if by chance he were to do so that his art would not radically suffer. Burra has made a number of landscapes of Rye and the country round about, which not surprisingly reveal a special perceptiveness, but were he to move elsewhere his art would not be in the least degree affected nor I think—apart from the acute discomfort of picking up roots, even from an unloved place—would his way of life.

After I had looked through all his work he suggested we should go into the garden. The gentle movement—we spent several hours perambulating there—seemed to stimulate him. He spoke of the artists he admired particularly among the living of Paul Nash and Wyndham Lewis; of his being haunted by the Spanish Civil War, and obsessed by Spanish civilization.

There was a picture that I especially wished to see again. 'A big picture of conquistadors' was how I described it: Edward looked puzzled and we recovered the painting I had in mind, which represented a group of soldiers of somewhat sixteenth century aspect, wearing scarlet masks appropriate to a Venetian carnival. 'Oh! *That* was the one you wanted, was it?' he said; 'but it's of *this* war: those are *British* soldiers just outside Rye.' Shortly after my visit *The Studio* offered to present a picture to the Tate and the Trustees readily accepted this splendid work, charged with the energy apparently so lacking in the artist himself, and of a sinister strangeness. Concerned, I think, that its subject should not again be mistaken, he changed its title from 'Soldiers' (under which it was first shown at the Redfern Gallery towards the end of the year) to 'Soldiers at Rye'.

Although all his pictures represent specific themes, he does not give them titles until their exhibition is intended. 'Then somebody comes along,' he explained, 'and stamps them with my signature with a rubber stamp, and presses me to invent titles for them.' Indeed there is an element of the unconscious about his pro-

cedures. 'Bring in a psychiatrist', he replied to an enquiry as to the meaning of one of his pictures, 'and we'll find out.'

The character of Burra's evolution is clear; the Second World War intensified the sense of tragedy evoked by the Spanish Civil War. One seemed to him to be the logical culmination of the other. The themes often drawn from the Mediterranean brothel or sailors' bar were no longer adequate to express his agonized awareness of the dark tide of savagery that was transforming the world as he had known it. At a certain level artists must enjoy what they represent. I remember artists in both World Wars being distressed by the dichotomy set up in their minds between their exhilaration by the spectacle of devastation and their utter abhorrence of its cause. The vein of sardonic humour with which Burra viewed the war is implicit in the sentences which follow. 'About 2 days or so after you left,' he wrote in a letter dated 1 October 1942, 'a bomb or so fell round the cinema suddenly turned into one of its own news reels. I came on a very *romantic* scene, "improved" into the loveliest ruin with a crowd of picturesquely dressed figurents poking about in the yellowish dust. Many more bombs and ye antiente towne really won't have a whole window left let alone a ceiling up—a very pretty little late eighteenth or early nineteenth Wesleyan Chappell went as well in the hubbub. I now notice an anti-aircraft gun outside the door.' (When the family moved from Springfield after the war their new house was built on the site of the ruined chapel, hence its name 'Chapel House'.)

The same spirit animates—more vividly—passages in an undated letter to other friends evidently written about the same time. 'Christmas night, the night before Christmas as a matter of fact the fun was so fast and furious in ye antiente towne that a Canadian was kicked to death and all the dances closed down by the military police on new year the Canadians came back all ripe for a revenge but found the midgets from Rochdale here shut up in their tumble down residences glaring from behind broken panes with military police parading up and down. . . . the days pass with many a jest and quip. Also as I was about the approach the level crossing I heard what I thought was machine gun practice, but oh dear me, it was nothing of the kind. It was the real thing . . . they did it again last

Friday. Always when I'm going down to buy cigarettes . . .' And 'An American citizen now he is—with a special "pardon" for a murder he committed in that state or an attempted one I'm not sure—but of course in a nice way—it was for the party . . .'

The heightened sense of tragedy evoked by the Spanish Civil War was expressed not only in paintings with military themes such as 'Soldiers at Rye', 'Silence' representing a macabre figure smiling at a bomb-devastated street, of 1936, 'War in the Sun' of 1948 or 'Camouflage' of the same year, but in religious pictures such as 'Holy Week, Seville', 'Mexican Church' (at the Tate), 'The Vision of St. Theresa', all, too, of 1938, a particularly productive year. Religious subjects—although he is not a practising member of a Christian church—have continued to preoccupy him from time to time. In his 1952 exhibition at the Lefevre Gallery he showed 'Christ Mocked' (at the National Gallery of Victoria, Melbourne), 'The Expulsion of the Money-Lenders', 'The Entry into Jerusalem' (at the Beaverbrook Gallery, New Brunswick, Canada), 'The Coronation of the Virgin', 'The Pool of Bethesda' (bought by the Methodist Church) and 'Joseph of Aramathea'.

Parallel with the growth of his tragic sense of life has been that of the perception of the elements of strangeness in everyday things. From his earliest days he has been obsessed by the quality of strangeness, but then he expressed it mainly by the depiction of themes strange in themselves, of which 'John Deth', although a conspicuous example, is only one among many. But from the 'fifties his work shows this heightened awareness of the strangeness in everyday things. In for instance 'Owl and Quinces' or 'Bottles in a Landscape' (both of 1955), it is as though he had seen, for the very first time, the stuffed owl and the four pieces of fruit at the foot of its mounting and the ten bottles standing on a path with houses and telegraph poles in the distance. The conviction and the skill with which he conveys his astonishment at the sheer strangeness of these objects compels us to share it. We are seeing a stuffed owl and bottles as though we had never suspected that such objects existed. But here again the suddenness of this preoccupation must not be exaggerated: the coffee-machine (and its reflection) in an early work, 'French Sailors', the big bottle in the foreground of 'Rossi' earlier

referred to, the buildings in 'Harlem' of 1934 (at the Tate) are examples of it selected at random; while his perception of the various qualities of cheap textiles has always been acute. Earlier, however, owing to the bizarre or nightmare character of his subjects, this strangeness was less conspicuous. Later, enhanced and applied to everyday objects in isolation, it has become one of the most impressive characteristics of his work.

Burra's art has undergone a further change. Until the later 'forties almost all of it represented people in their environment (occasionally strange non-human beings in theirs), but there has been a gradual shift of interest away from man to landscape and to inanimate objects. He confesses, as an artist, to a diminished interest in people, and more in his surroundings. He makes landscapes near his home in Rye and other regions which he visits, occasionally with his sister, in Yorkshire (where they stay with friends in Harrogate) and in Ireland. He makes no sketches on the spot but returns to Rye with his memory charged with subjects remembered selectively but in the utmost detail.

'There is a time-lag between my seeing a landscape,' he explained to me, 'and my coming to the boil, so to say, but when I go back there, I'm always puzzled by what I've left out.'

As was inevitable, with the diminution, although far from extinction, of his interest in his fellow-men the satirical tone of his art has undergone a parallel decline. Discussing this development, I recalled that David Low had said to me that something of its former satiric bite had gone out of his caricature, and that the cause was clear, namely that the world had become so horrific a place that much was beyond the reach of satire. 'What,' he had asked me, 'can a satirist do with Auschwitz?' 'I entirely agree with Low,' Burra said, 'so many appalling things happen that eventually one's response diminishes. I didn't *feel*, physically, for instance, the shock of Kennedy's assassination as I would have done before the war.'

If Burra has become less concerned than he was with subjects inherently dramatic and sinister, he is able to imbue a stuffed owl, a few bottles or even a bunch of flowers with a dramatic and sinister ambience. This ability, this compulsion springs not from fancy or transient mood, but from a consistent attitude to life.

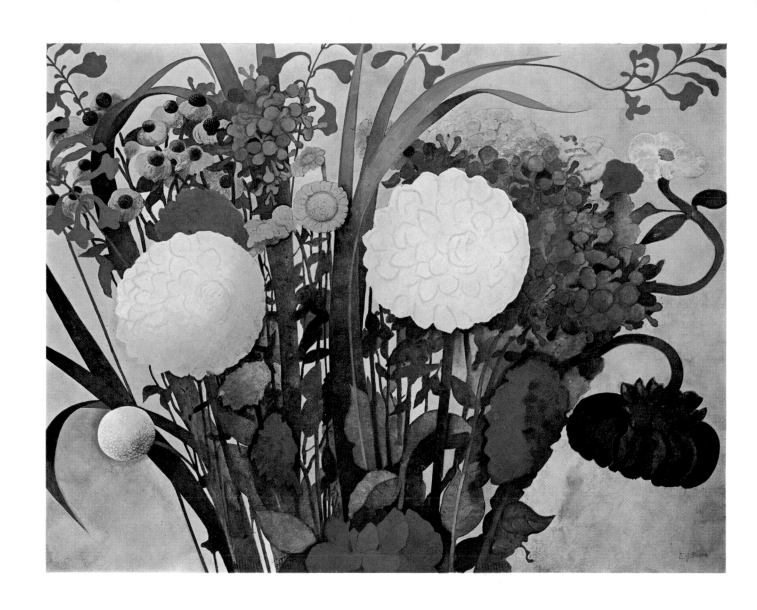

120 FLOWERS, c.1965
 Watercolour, 30¾ × 40½ (78.1 × 102.9)
 Sir John and Lady MacLeod

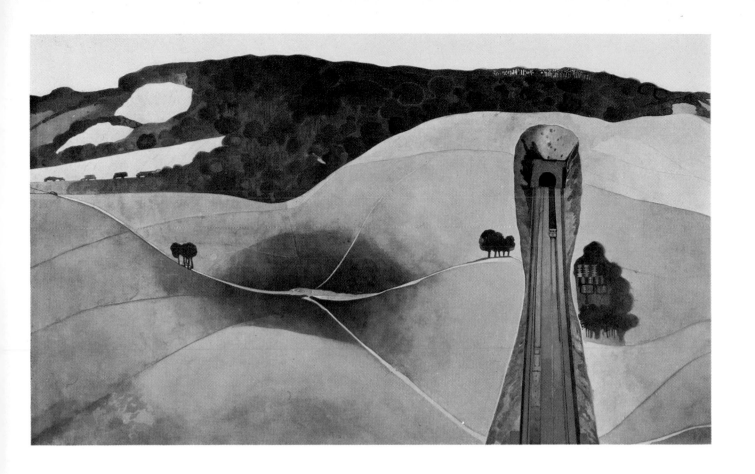

121 THE TUNNEL, 1966
 Watercolour, 30½ × 51 (77.5 × 129.5)
 George Melly

'*Everything*,' he said to me, '*looks* menacing; I'm *always* expecting something calamitous to happen.'

The diminution of his interest in people and the drama of their situations is reflected by their replacement, frequent by the 'sixties, by sculpture, which enables him to represent the human figure without concerning himself with the human personality. So highly evolved has become his power of endowing inanimate objects with the quality of mysterious threat that human beings have become less and less necessary features of his art.

The imagery of Burra, the solid figures unmoving, unblinking, charged with nameless menace, yet animated by touches, here and there, of schoolboyish humour; landscapes, motorcars, lorries, excavators, flowers too, with obscure, disturbing overtones, constitutes, in T.S. Eliot's phrase, 'a more significant and disciplined kind of dreaming', though it has often more of the character of a nightmare than a dream.

Edward Burra is an essentially private person—who takes pride in never 'giving anything away' about himself, so I will not intrude much upon his privacy. But a few more words about the man may amplify this brief introduction to the artist.

He is without ambition of any kind, either professional or personal. John Banting, who was with him when the offer of a CBE arrived, wrote, he told me, the letter of acceptance on his behalf in case Burra should forget to do so. Invited to become an Associate of the Royal Academy, he did not even reply. If his work sells, he is mildy pleased; if it does not, he is indifferent; he requires only sufficient income to keep up Springfield Cottage (where he has lived since 1968), to afford his bi-weekly visits to London and his occasional expeditions with his sister, but it has almost always sold well. He rarely reads newspaper notices of his exhibitions.

The extraordinary strength of his will compensates amply for the weakness of his constitution and it gives him untiring energy. He walks long distances, stays up late, requires no more than five hours sleep, and works every day from eight or eight-thirty; rests for an hour or so in the afternoon in order to read (he is a voracious reader in Spanish, French, as well as English, of everything from

the classics to science fiction) and resumes work later on.

There is one respect in which artists may be divided into two categories: those for whom the creation of a work of art is an extension of themselves to be, if possible, retained or else in some way safeguarded, and those for whom such creation is an act of parturition. Stanley Spencer, to take a conspicuous example, even at times of extreme poverty never parted with his work without reluctance (aside from landscapes, which he painted specifically for sale) and never at all—so far as I am aware—with any of his sketchbooks. It remained intimately, obsessively, a part of himself. Francis Bacon, on the contrary, would not object (though he might be surprised) if the purchaser of one of his paintings promptly destroyed it. Burra in this respect resembles Bacon: he loses his work and often forgets it. If a friend shows him a work lost or forgotten he will look at it with relish or dismissal, just as though it had been made by someone else, in particular laughing at any feature of it that strikes him as comic or absurd.

However indifferent the general public, his work, even routine life drawings made as a student, has always been treasured by his circle of intimates as well as a slowly growing number of others. It is my own long-held conviction that posterity will share the admiration of his friends rather than the indifference of the general public.

3 TARTS, 1923
Pen and ink, 15 × 11
(38 × 28)
*Mr and Mrs Nicholas
Jones*

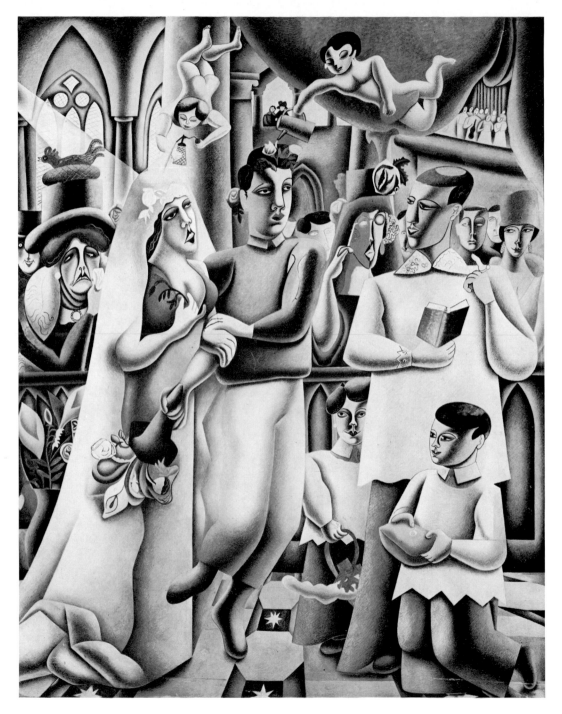

12 MARRIAGE A LA
MODE, 1928
Watercolour
$24\frac{1}{2} \times 20 \, (62 \times 41)$
Barbara Ker-Seymer

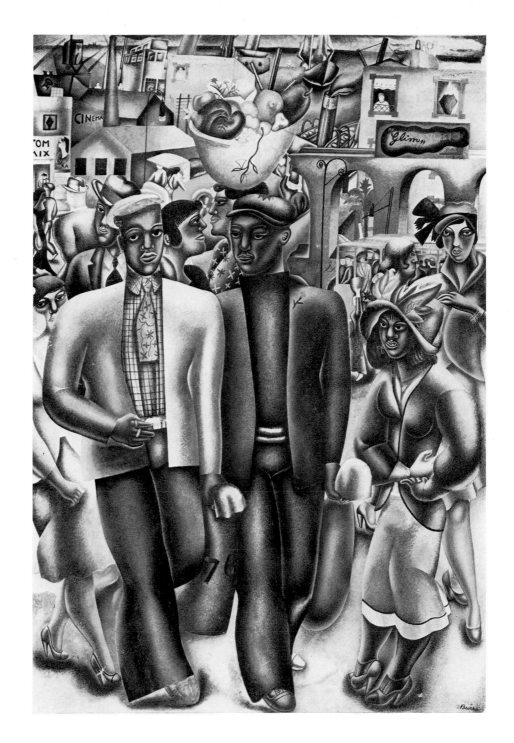

4 MARKET DAY, 1926
Watercolour, $21\frac{3}{4} \times 14\frac{3}{4}$
(55×37.5)
Private Collection

13 SHOW GIRLS, 1929
Pencil, 30 × 14¾ (76 × 37.5)
Mrs Desmond Corcoran

EARLY NIGHT, 1930
Pen and ink/wash
$19\frac{3}{8} \times 15$ (49 × 38)
Private Collection

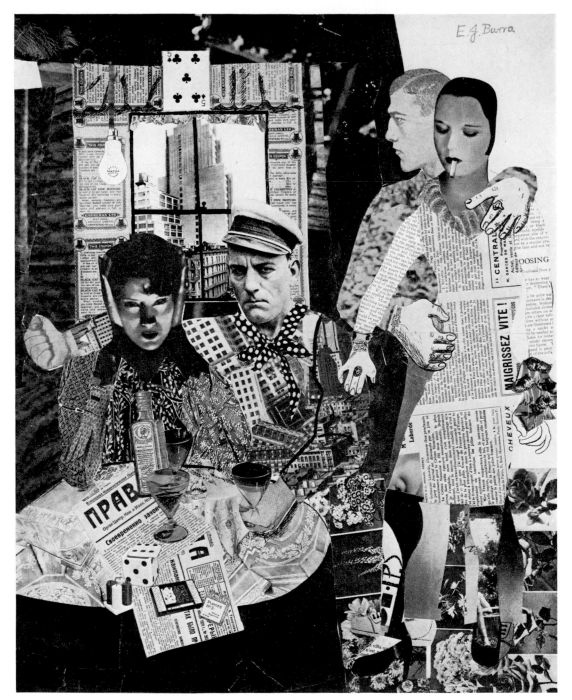

18 COMPOSITION
1929
Collage, 15 × 11
(38 × 28)
Lefevre
Gallery

Opposite
28 KEEP YOUR
HEAD, c.1930
Collage and pencil
$23\frac{1}{2} × 21 (59.5 × 5$
Tate Gallery

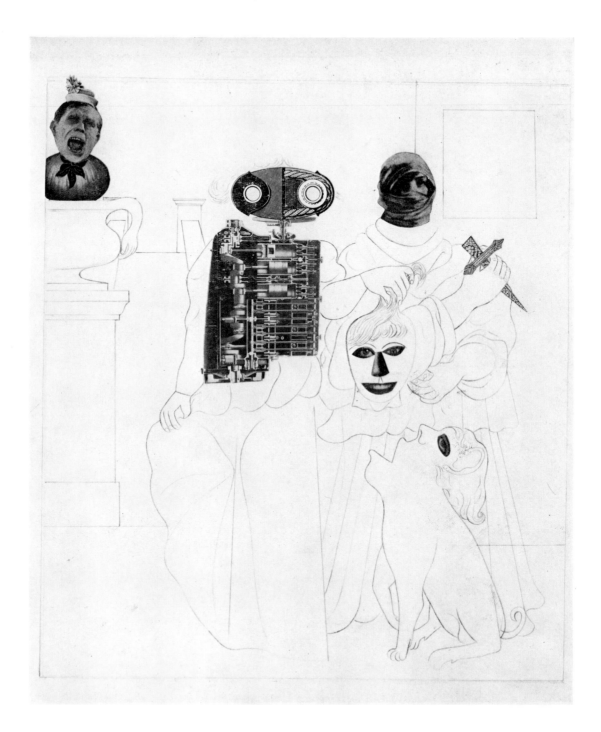

44

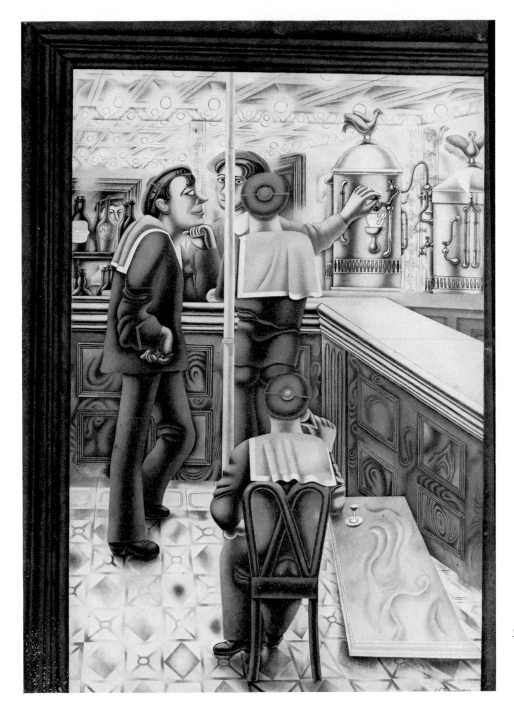

22 3 SAILORS AT A BAR, 1930
Watercolour, $26\frac{1}{2} \times 19$
(67.3 × 48.2)
Private Collection

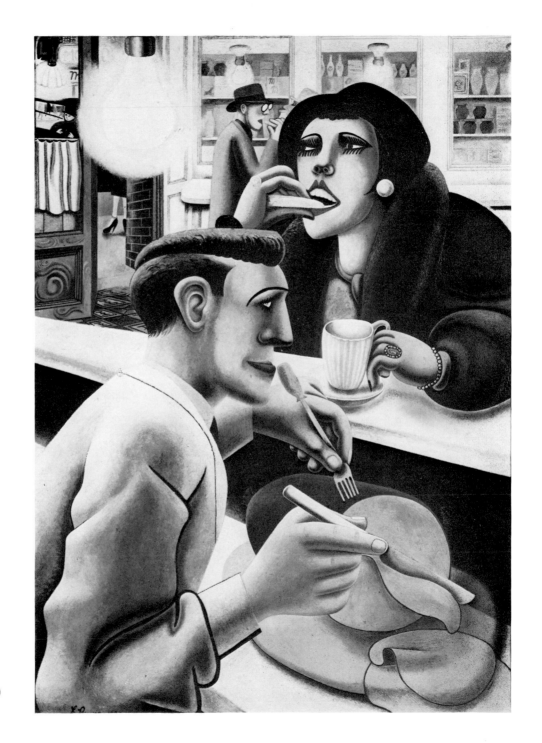

23 THE SNACK BAR, 1930
Oil, 30 × 21¾ (76 × 55)
Helen Grigg

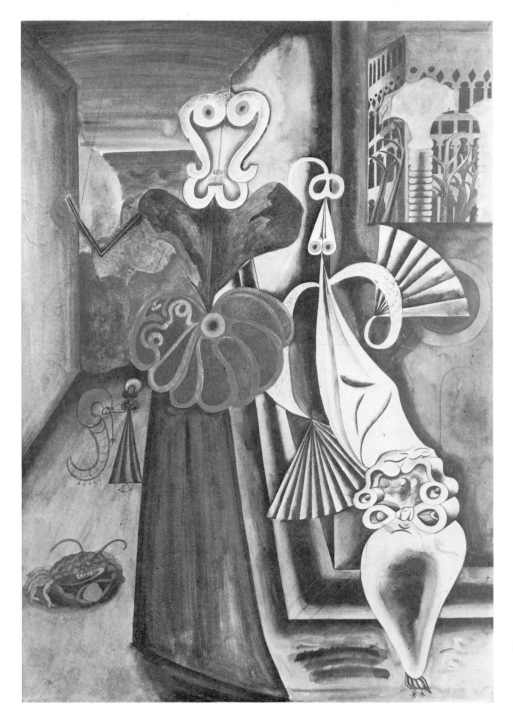

24 THE DUENNA, 1930
Watercolour, $21\frac{3}{8} \times 14\frac{3}{4}$
(54.5×37.5)
Private Collection

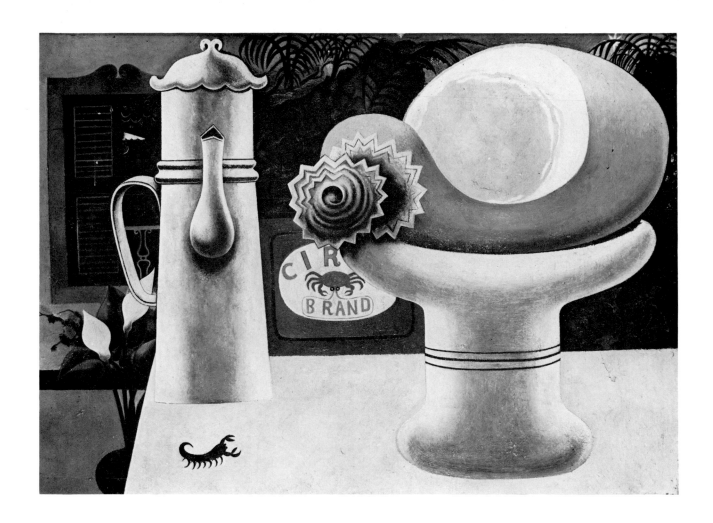

30 THE HAM, 1931
 Oil, 20 × 27 (51 × 68.5)
 Barbara Ker-Seymer

E.J.Burra

38 THE PARTY, c.1934
Pen and ink
21 × 17½
(53.5 × 44.5)
*Mr and Mrs
A. D. Pilcher*

7 SUPER CINEMA
c.1934
Pen and ink, 19¼ × 15
(49 × 38)
Anthea Pooley

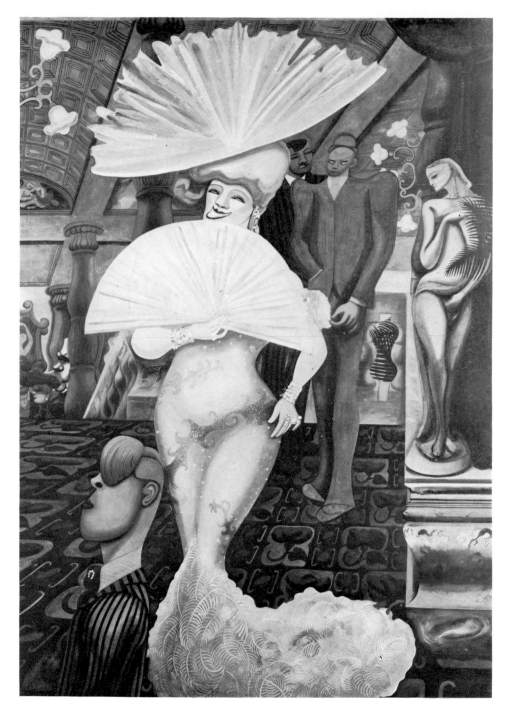

50 MAE WEST, 1935
Watercolour, 30 × 22
(76 × 56)
Desmond L. Corcoran

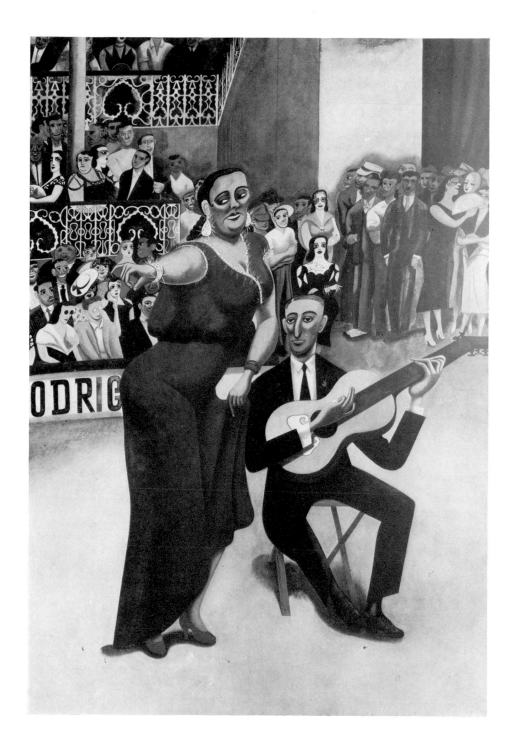

47 MADAME PASTORIA, 1935
Pencil, $25\frac{1}{2} \times 17\frac{3}{4}$ (65 × 45)
Desmond L. Corcoran

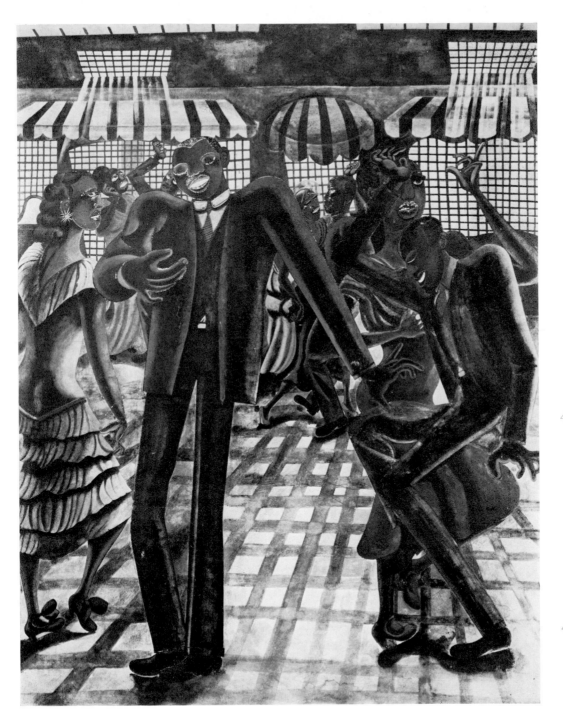

49 SAVOY BALLROOM
HARLEM, 1935
Watercolour
$23\frac{3}{4} \times 18\frac{1}{2}$
(60×47)
Private Collection

Opposite
46 EL PASO, 1935
Watercolour
$52\frac{1}{2} \times 44$
(133×112)
D. W. E. Eckart

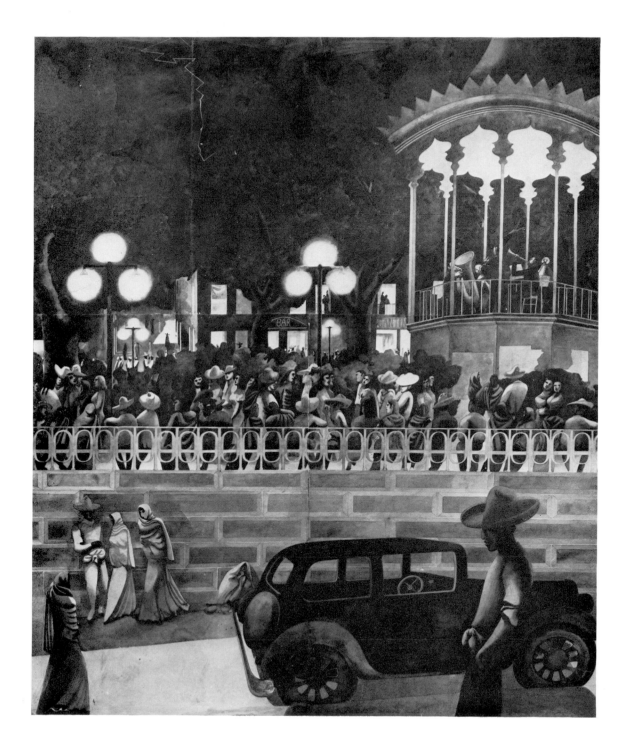

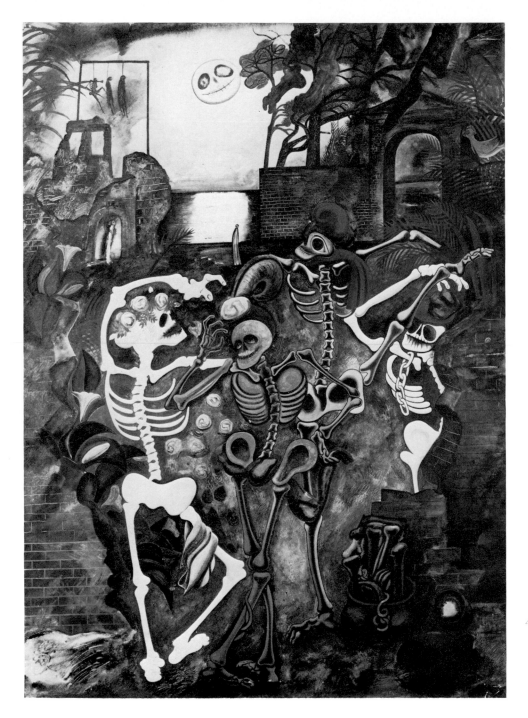

41 DANCING SKELETONS
1934
Watercolour, 31 × 22
(75 × 56)
Tate Gallery

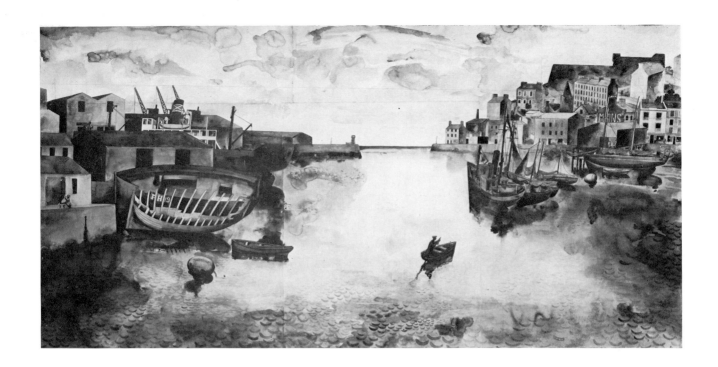

53 HARBOUR WITH BOATS, PLYMOUTH, 1935
Watercolour, $29\frac{1}{2} \times 56\frac{5}{8}$ (75×144)
Kuhn, Loeb & Co. International

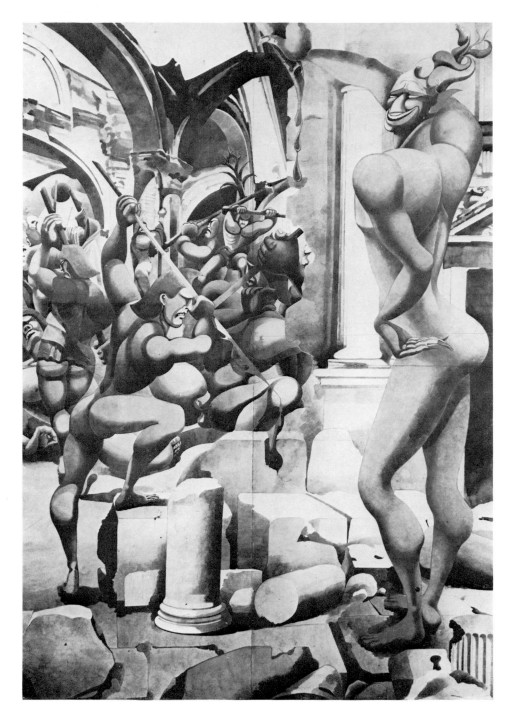

70 BEELZEBUB, c.1938
Watercolour, 61 × 44
(155 × 112)
Lefevre Gallery

Opposite
65 THREE FATES, c.1937
Watercolour, 52 × 44
(132.1 × 111.8)
Lefevre Gallery

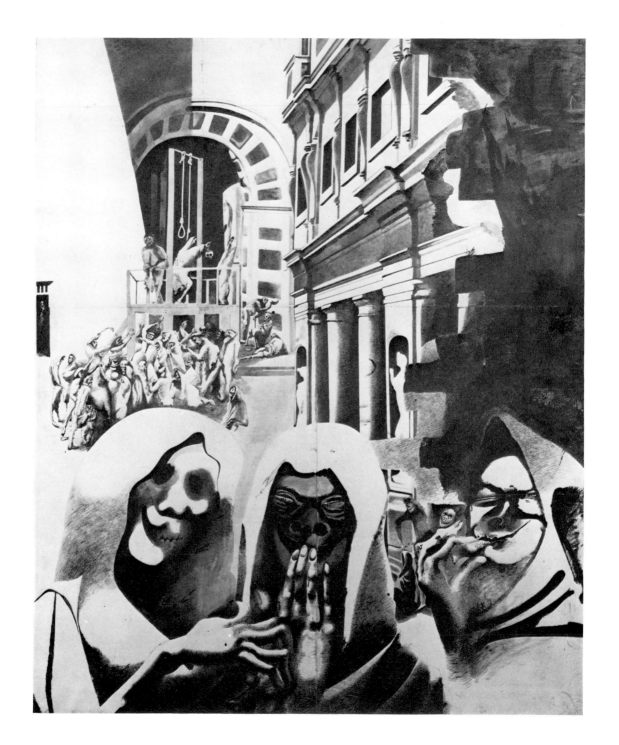

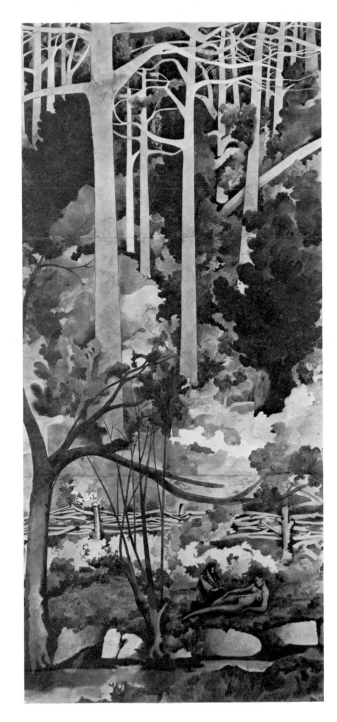

64 TREES, c.1957
Watercolour, 65 × 31 (165.1 × 78.7)
Lefevre Gallery

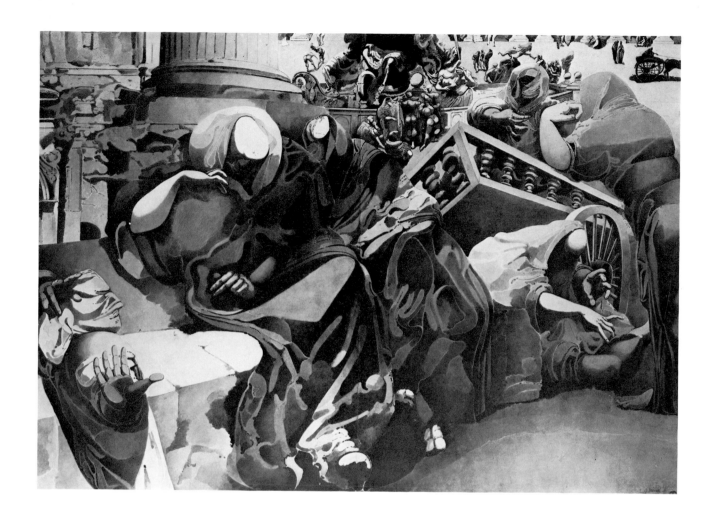

71 OLD IRON, c.1938
 Watercolour, $38\frac{1}{2} \times 51\frac{1}{2}$ (97.8 × 130.8)
 Lefevre Gallery

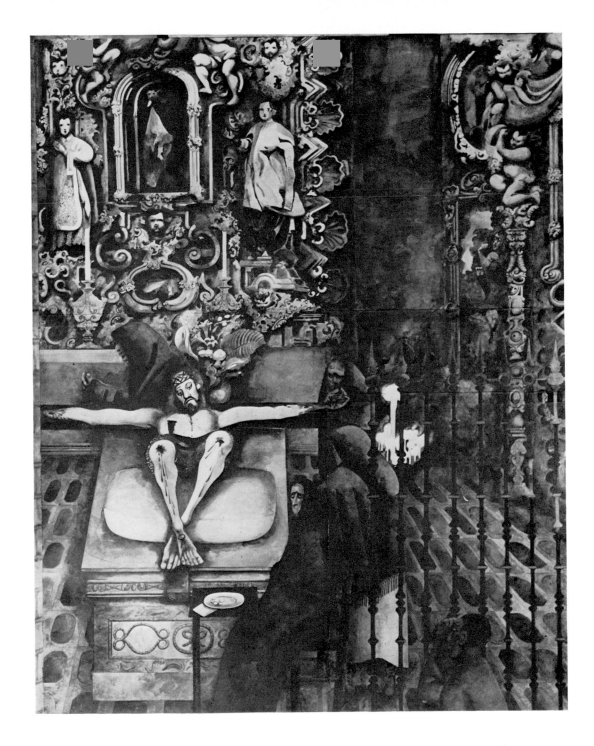

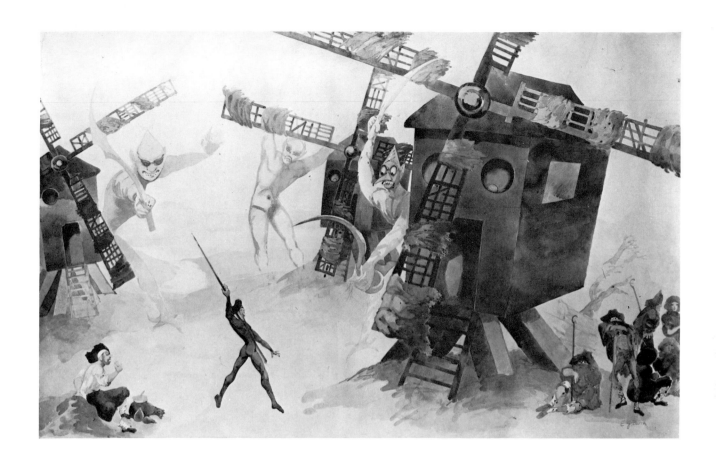

85 SET FOR DON QUIXOTE NO.1, c.1948
Watercolour, 26 × 40 (66 × 101.6)
Lefevre Gallery

Opposite
68 MEXICAN CHURCH, 1938
Watercolour, 51½ × 40⅜ (131 × 102.5)
Tate Gallery

62

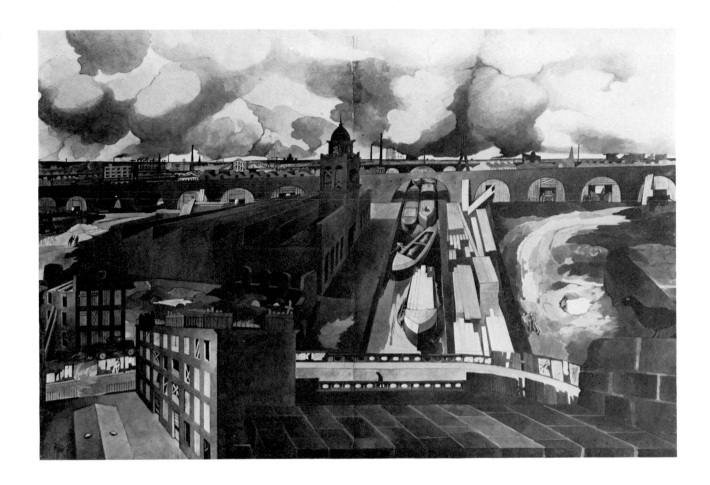

79 RAILWAY VIADUCT, 1947
 Watercolour, 31 × 44 (78.8 × 111.8)
 Private Collection

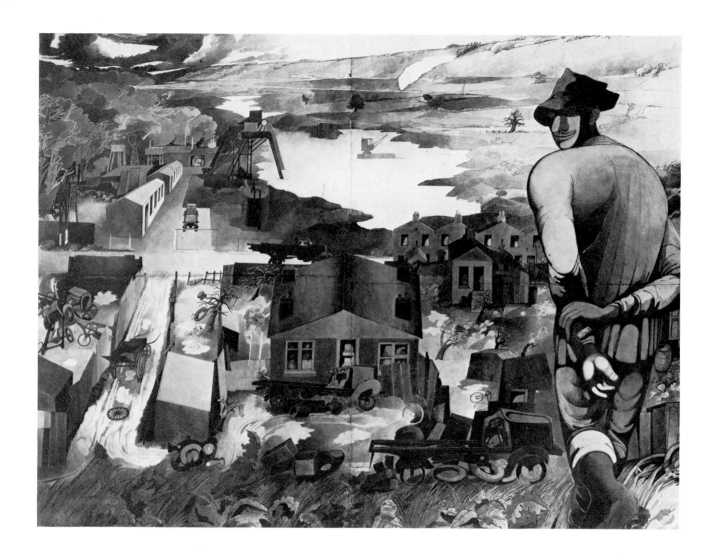

80 RYE LANDSCAPE WITH FIGURES, 1947
Watercolour, 27 × 40 (68.6 × 101.6)
Cecil Higgins Art Gallery

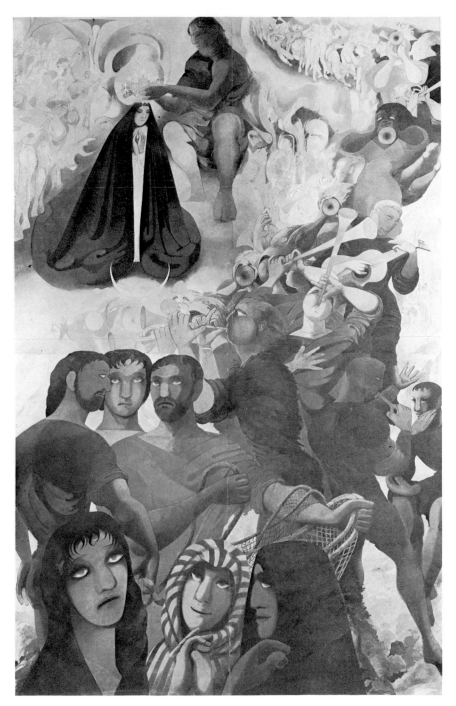

90 CORONATION OF THE VIRGIN
 c.1952
 Watercolour
 80 × 52 (203 × 132)
 Michael Benthall

Opposite
88 THE MOCKING OF CHRIST, 1952
 Gouache on paper, 53¾ × 52
 (136.5 × 132.1)
 University of Dundee

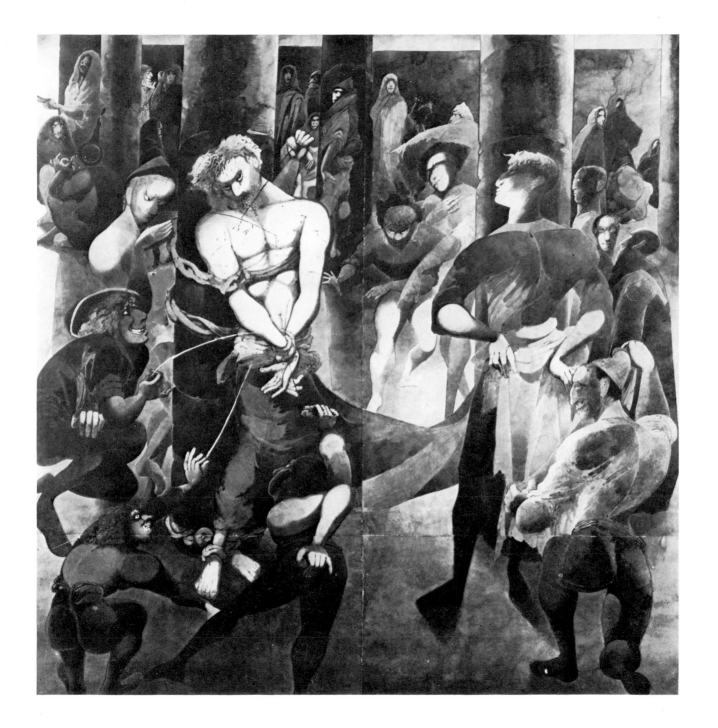

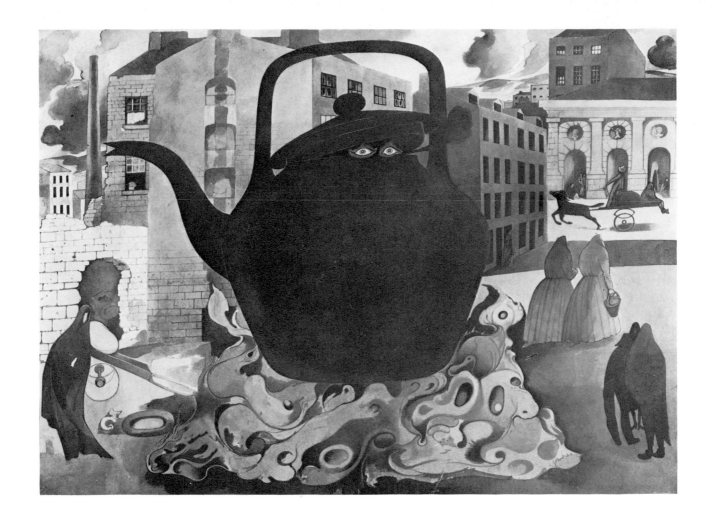

84 IT'S ALL BOILING UP, 1948
Watercolour, 23 × 31 (58.4 × 78.8)
D. W. E. Eckart

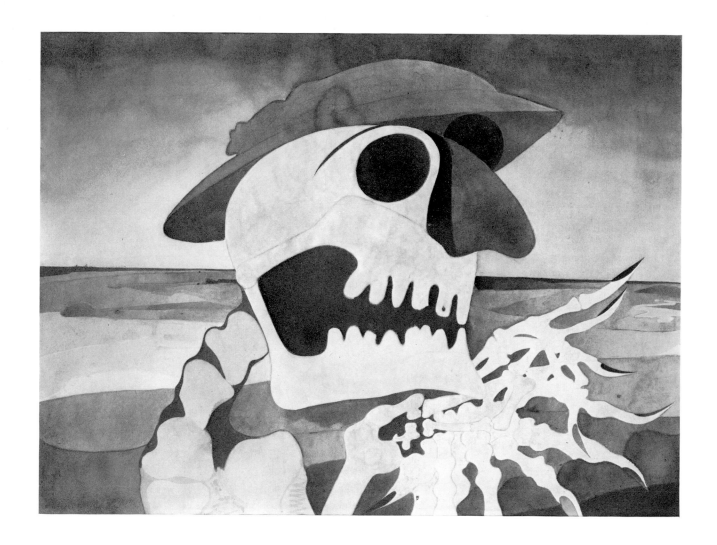

76 SCULL IN LANDSCAPE, c.1946
Watercolour, 21¾ × 30 (55.2 × 76.2)
Hamet Gallery

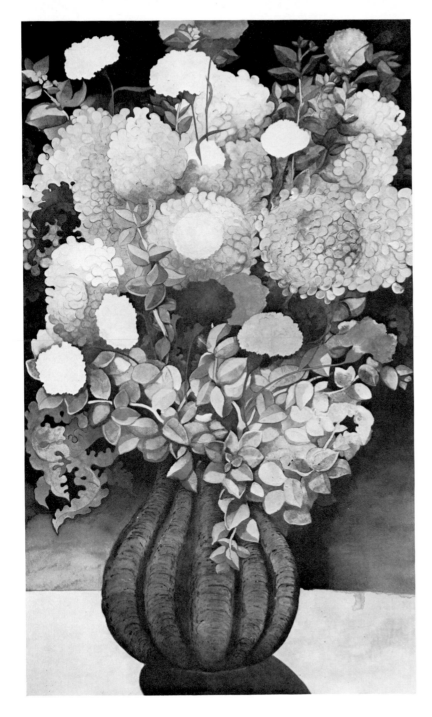

105 FLOWERS IN A POT, c. 1957
Watercolour, 53 × 31½ (137.1 × 83.8)
Private Collection

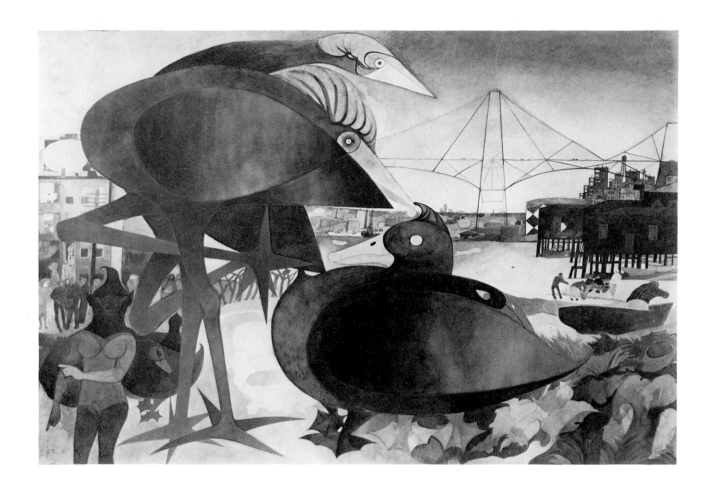

98 ESSO, c.1955
Watercolour, $28\frac{1}{4} \times 41$ (72×104)
J. O'Brien

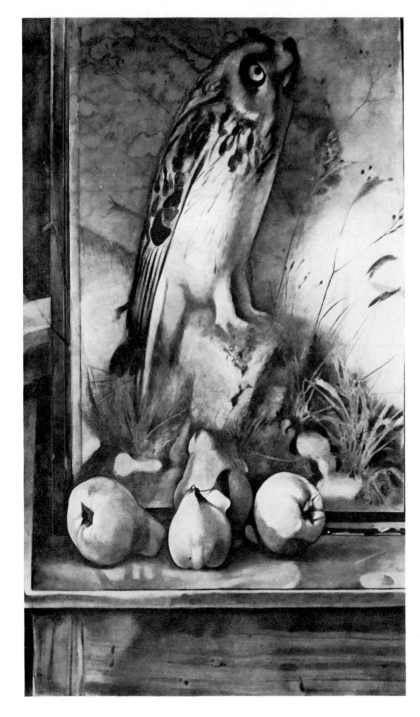

101 OWL AND QUINCES, c.1957
Watercolour
52 × 32 (132 × 81.5)
A. F. Roger

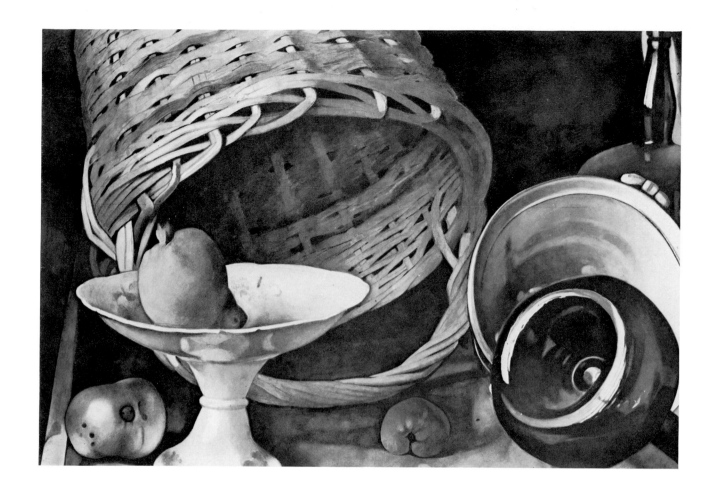

103 STILL LIFE WITH BASKET, c.1957
Watercolour, $28\frac{5}{16} \times 40\frac{15}{16}$ (72×104)
J. G. Aspinall

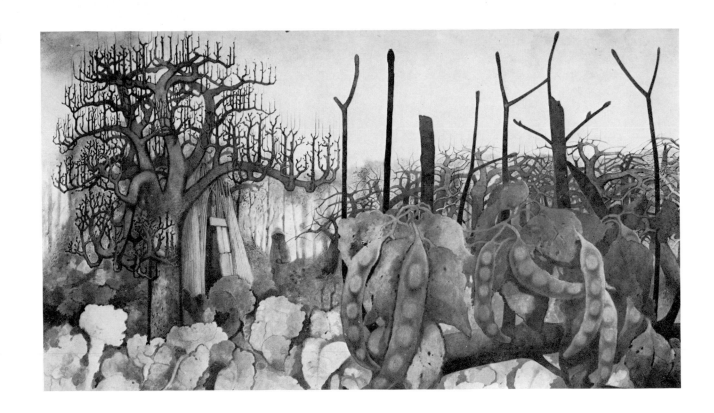

108 LANDSCAPE WITH BEANS, c.1959
Watercolour, $30\frac{1}{4} \times 53\frac{1}{2}$ (76.9 × 135.9)
Private Collection

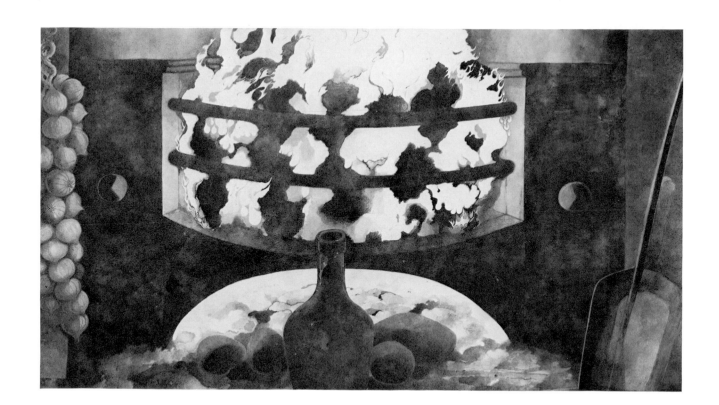

110 THE FIRE, 1960
Watercolour, 30½ × 53 (77.5 × 134.6)
Lefevre Gallery

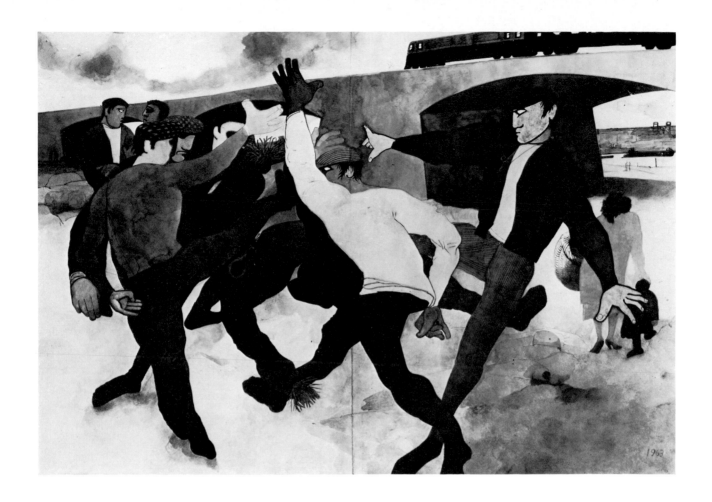

111 THE STRAW MAN, 1963
Watercolour, 31 × 44 (78.8 × 111.8)
Private Collection

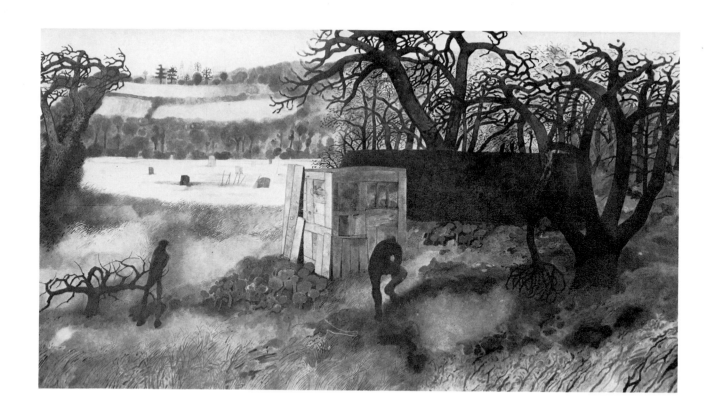

113 THE ALLOTMENTS, c.1963
Watercolour, 30 × 52½ (76.2 × 133.3)
Sir Antony Hornby

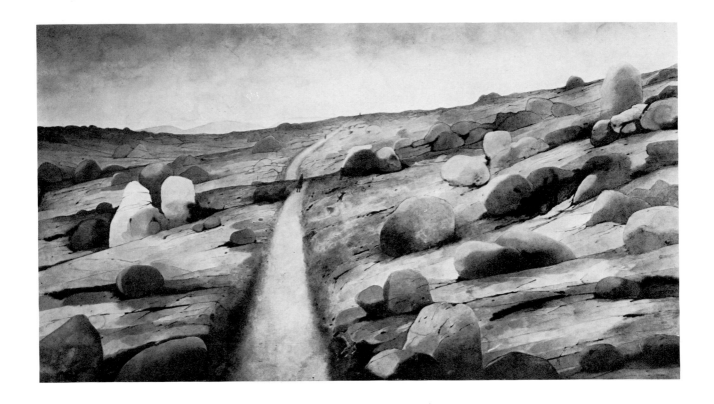

112 CONNEMARA, c.1963
Watercolour, 29 × 53 (73.7 × 134.6)
Vickers Limited

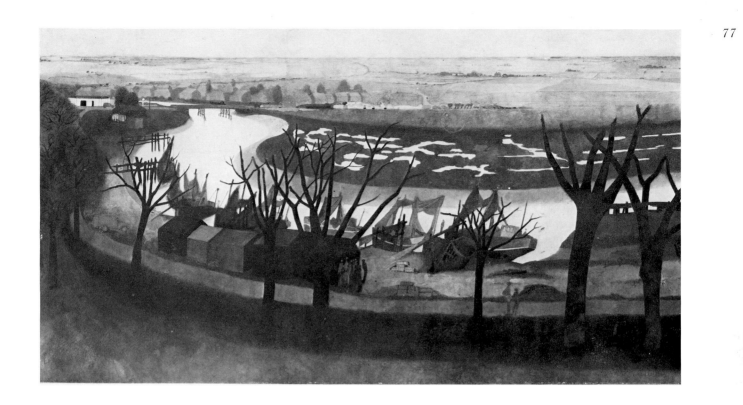

115 LOW TIDE NEAR RYE, c.1963
Watercolour, 29¾ × 52½ (75.5 × 133.3)
Joseph Janni

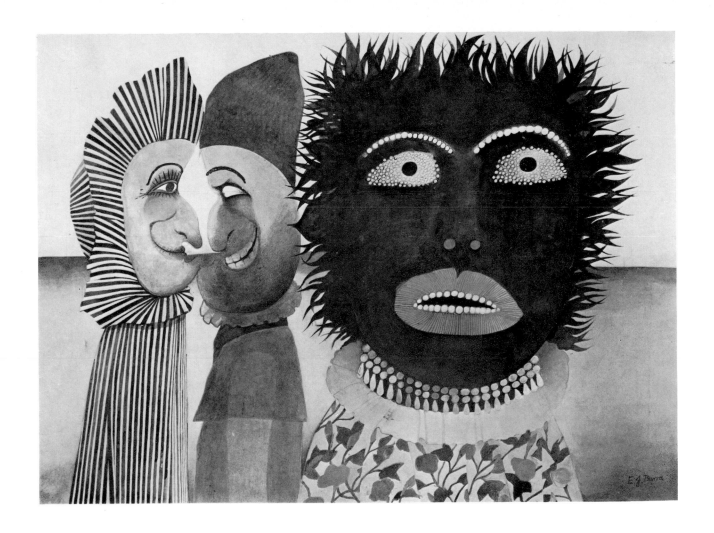

109 PUNCH AND JUDY, 1960
Watercolour, 21½ × 29½ (54.6 × 74.9)
Lefevre Gallery

Opposite
117 THE GOSSIPS, 1964
Watercolour, 30¼ × 26¼ (76.8 × 66.6)
Lefevre Gallery

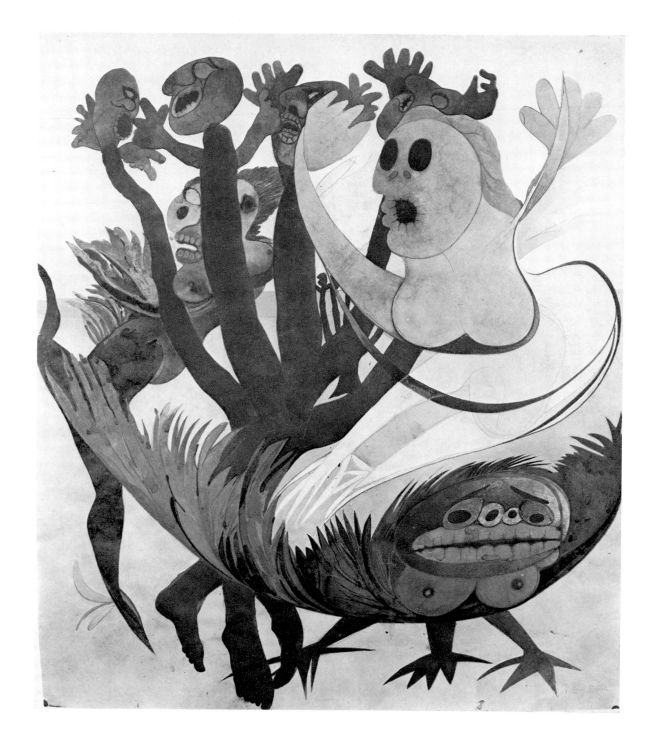

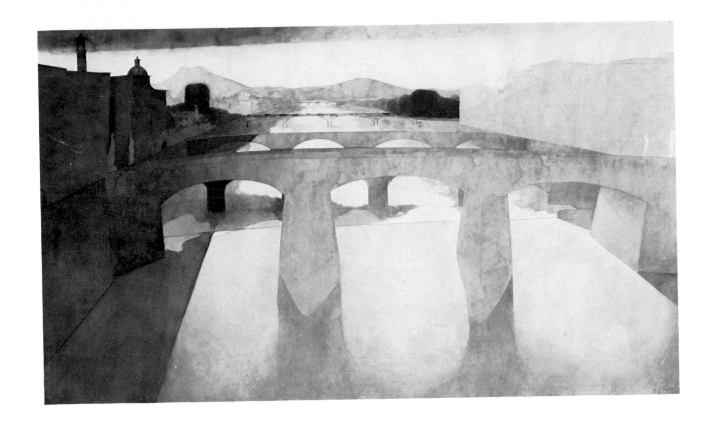

130 VIEW AT FLORENCE, 1967
 Watercolour, 32 × 52 (81.2 × 132.1)
 A. F. Roger

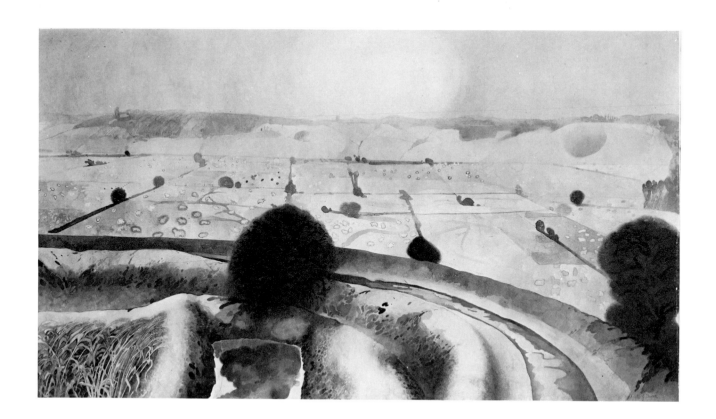

133 FROZEN LANDSCAPE, c.1969
Watercolour, 31 × 52½ (78.8 × 133.3)
Dame Cicily Andrews, DBE

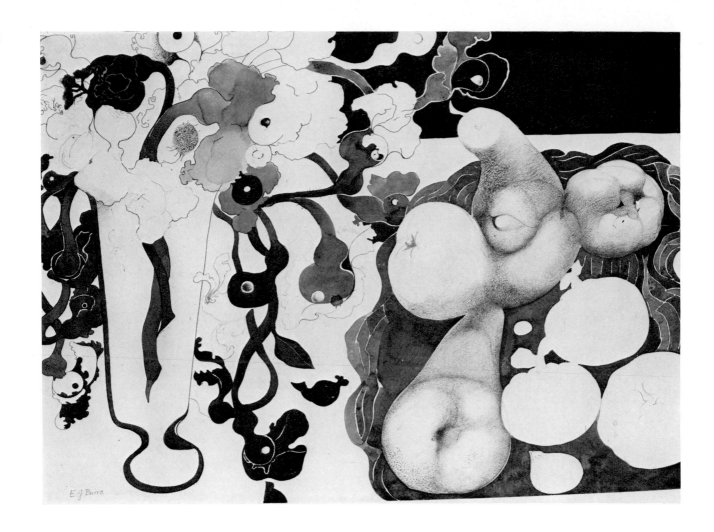

131 PEARS, c.1967
Watercolour, 22¼ × 31 (56.5 × 78.8)
Mrs Gordon Binnie

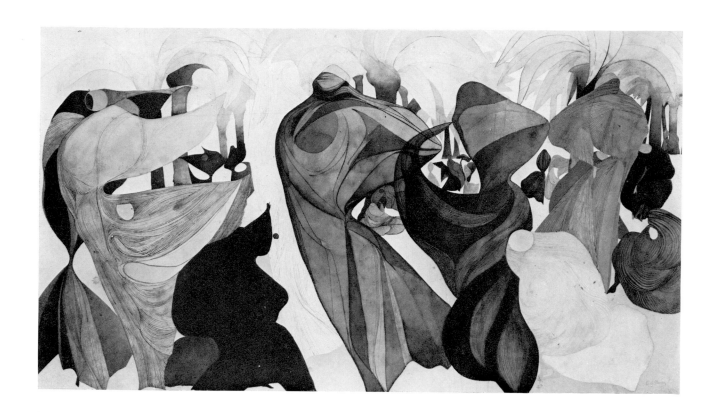

142 WHIRLING DERVISHES, 1971
Watercolour, 30¾ × 53 (78.1 × 134.6)
Private Collection

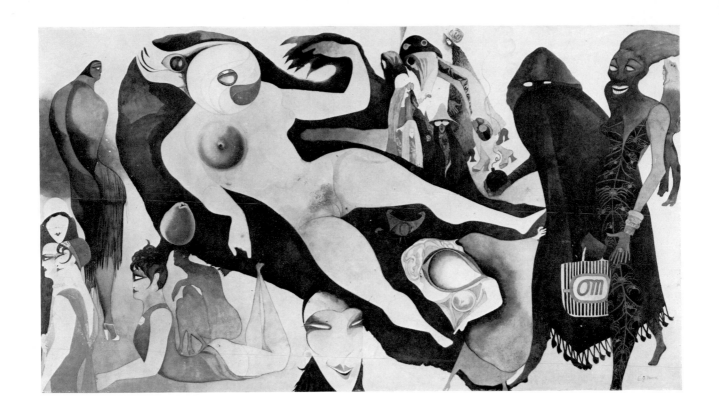

141 IN'CUBI AND SUCC'UBI, 1971
 Watercolour, $32\frac{3}{4} \times 55$ (83.2 × 139.8)
 Douglas Villiers

Letters and Postcards

The images on cards and the letters which Burra and his friends exchanged can not be linked in a very literal way to his paintings but they give a very vivid impression of the wide range of things, especially films and theatre, and the people that interested and excited him.

A very small selection of cards and excerpts from Burra's letters of the 20s, 30s and 40s is printed here which serves to no more than hint at the wealth that exists and to hint at its strong individual character and sensibility. Only one letter is printed in full, that from New York, and a page is reproduced in facsimile, which is typical of those in which drawings and handwriting are mixed.

Very few letters are dated; the dates given are sometimes taken from the franking on the envelope and sometimes deduced from the contents of the letters.

1 *To* BARBARA KER-SEYMER *Paris, January 1927*
We have just been to the last days of Pompei
dear which I adored my dear the orgy in the
temple of Isis excited us so we shivered all
over. The high priest and his protege reclined
in a bower of roses & in every direction there
were Doctor Blotto's living statuary & at the
back there was a mummy case in which their
appeared a creature all wrapped up in ban-
dages who tottered swaying forward & dear
the bandages began to unrole disclosing the
serpent of old nile in no clothes but a small
sized Kotex sanitary pad with 1 tasty diamond
placed in front in a commanding position she
then did a dreadful dance and hurled herself
onto the high Priest just like this [drawing]
and then covered up her bust all too modest
with rose buds it was quite a treat dear I can
tell you . . .

2 *To* BARBARA KER-SEYMER *Cassis,*
October 1927
. . . I have bought such a pair of shoes in
Marseilles for 17/6 in 2 shades of brown or I
may say tan a much favoured mode about

here is cream coloured sort of glace kid with
a tan toe cap and a sprinkling of tan lines here
and there [drawing] also sham crocodile
uppers are a perfect rage tho of course you know
dear I like everything to be real you know
realy good . . .

3 *To* BARBARA KER-SEYMER *Springfield, 1928*
. . . Mae West remains my favorite since
seeing Belle of the 90*s* which I enjoyed more
than anything Ive seen for a long time my
favorite scene is when she stands draped in
diamonte covered reinforced concrete with
a variety of parrots feathers ammerican
beauty roses & bats wings at the back and
ends up waving an electric ice pudding in a
cup as the statue of Liberty Some of the sets
I thought were the best Ive seen I cant wait
to see "I'me a lady now" all the Hollywood
cement factories are working over time.

4 *To* BARBARA KER-SEYMER *Springfield, June*
1928
. . . we went to "The street" & "Blackmail"
which was glorious I've never seen such a

programme my dear we waited till ten past 2
for you and Clover showd us her engagament
in Hungarian papers & then we went in.
You must go old Ellen Richter surpasses
herself she first appears as 2 dainty legs in
+ 4s sticking out from under her car so of
course our ruin of a Jack T gives them a pinch
& out comes Ellen in a neat Austin Reed pull
over & leather airmans helmet, very fat and
walking with her feet turned straight out she
was so good tho especialy in the drammatic
parts when she went to get her sisters letters
("Evi Eva" who was like this [drawing]) with
an immense mop she wore the most lovely
clothes very tawdry with a striped net bodice
& shoulder straps. as for shoes my dear, sort
of Peter Yapp mixed strangely with pinet and
walked well down, Ellen was not to be outdone
however & appeared in a chic coat trimmed
with flounces of black and white wool exactly
like the druids beards in the imortal hour
old Ellen had been at them with the sheers
when they were asleep I'me sure she also had
a chic evening gown made of tramlines of
diamonte flounces of net draped velvet this

is exactly like the dress [drawing . . .] it caused
quite a furore . . .

5 *To* WILLIAM CHAPPELL *Springfield, 1929*
(on back of a portrait postcard of himself as
a boy)
Ah jeunesse jeunesse The latest photo of
Edward Burra remarkable young Artiste who
(according to the Graphic) has lived all his life
in a Sussex village & is entirely self taught.
I'me having all my other photos suppressed
none are sufficiently jeune . . .

6 *To* WILLIAM CHAPPELL *Toulon,* c.*1929*
. . . We also went to Galerie Leonce Rosen-
berg. such a show my dear of Metzinger
Chirico Gino Severini Herbin Ozenfant &
others (Max Ernst) all very abstract I've
never seen such a beautiful show for years.
Leonce R was very charming theres a lovely
surrealiste peintre called Viollier all red plush
birds' nests in trees with the Venus de Milos
head & shoulders coming thru the top. I
believe some of them may get shown at the
Leicester. Now we know where John Arm-

strong has been says Margaret glancing round. I went to Anna Sten & J Howal Samborski in The Yellow Ticket in Paris the brothel scene is a dream it opens with 1 very thin sinuous pros & a very small pros doing a dainty cottillon round the room then every one joined in and did the lancers dressed in ruinous old wrappers with holes in the edge, where they'd caught their feet then spring came & there was a sudden flash of rippling rivers bursting buds & falling wombs & then a flash back to the brothel where the eternal lancers went on & on then a flash of cornfields and back to the brothel where on went the lancers tho the flesh cracked neath the painted grin you must go if it comes to the film society if only for the brothel.

7 *To* BARBARA KER-SEYMER *Springfield, postmark June? 1930*
. . . Thank you for the 2 daintie pc's they will be so useful for my new pictures we never bother to paint in this part now we just stick on things instead. I have such a twee one started of 2 ladys walking along with pieces of motor engine for heads & a table at the side made of anita paiges legs with a drawn in top and a large dishful of heads reposing on it its fascinating . . .

8 *To* BARBARA KER-SEYMER *Paris, c.1931*
. . . yesterday nite I went to the Casino de P revue glorious my dear Ive never enjoyed anything so much for years. J[osephine] Baker rose out of a gilded casket in a green evening dress to the floor trimmed with diamonte & sang King for a day in English never have I heard anything so lovely She also appeared as a native maiden in a dramatic sketch which was glorious when she dis-

covererd her white beau was leaving for Paris she rushed at him & said Jeeem Jeeem ne partez pas emene moi avec vous Jeeem. She then flew in a rage & bit everyone then she was beaton by a slave driver & finally blown away in a hurricane just as her hut collapsed. She was saved by her pet ape. (Harry Pilcer in a doormat) she then sang J'ai deux amours mon pays & Paris. now my favorite theme song. There was also a venitian nomber with real doves & a boxing match between the Jackson boys my dear the voice of the chief Jackson!! Naow yew boys plai fayer cant you beaive like gentlemen. my dear I shall never rest till I go again Baker is lovely & their was a marvellous adagio team to say nothing of Miss Florence who does lovely front overs & back bends . . .

9 *To* BARBARA KER-SEYMER *Lyon, c.1932*
I do hope you like my new fangled pictures Im just crazy over bird folk now and in Lyon right this moment am studying bird folk from my window in the palace. We spent 8 hours sitting in the cafe Royal and Lyons corner house last night. I also visited the 2 cinderallas of Shepherds Market no sooner had little prince Bartholin & myself got in the house when in came Sophia Bunny Rogers a little princess and boy and we all started to talk of the cinema Sophie curled up & went off to sleep nestling in a packing case covered by 3 sheets of talc and ½ made celophane hats a few sheets of the NY evening graphic and 2 or 3 licquorice all sorts & gramophone records as a pillow also the sash of Bums window broke so her bedroom is impossible & of course you are coming to my little exhibition on the 24 or 25 May of bird lore at the Leicester Galls you certinly must not miss this

Oh why cant I be in Paris!! Bumble made us all jealous Dear Paris in the spring with chestnuts bursting in the Bois—But it is autumn now

10 *To* BARBARA KER-SEYMER *New York, Winter, 1933-4*

Well old dear

Here we are ensconced in a pitch dark apartment even at high noon you cant read without electric light New York would drive you into a fit never in my life have I seen such faces Harlem is lovely rather like Walham green gone crazy we do a little shopping on 116th st every morning there are about 10 Woolworths of all sorts and a McRorys chainstore also 40 cinemas & Apollo burlesk featuring "Paris in Harlem" which I am plotting to go to but wont be allowd to I can see. It must be seen to be believed instead of going to Juan Les pins I think next year you should come to New York as my pen doesnt do justice to it Sophie and I go out every morning and have breakfast at different quick lunchs we hope to try the Arabian nights luncheonette tomorrow The food is delish 40000000 tons of hot dogs & hamburgers must be consumed in NY daily and as for the pies and sodas 2 minutes after arrival we were being treated to sodas in ye patio soda shoppie done up inside with false windows with awnings in the mexican fashion Mae Wests new picture has just had a premiere to night I am mad to go Im sure you would like Times Square its just a fit of epilepsy non stop twitchery night and day. There was a jolly cocktail party the other day at which Dame Baldwin appeared and did she get a turn when she saw me walk in if the empire state building had crept in on all fours she couldnt have had a worse shock.

Taylor Gordon was there who is delightful also Douglas Parmenher and Esther Strachey whos face I couldnt take my eyes off she never stopped talking for one second she looked rather like this [drawing] only twitching continuously. Have only met one bevy of bogus so far at a dainty dinner party that Conrad Aiken asked me to they all sat round and listened to Bach and a terrific jew had such a charming pretty little french wife who had a school of the dance (in the Duncan Manner in the Catskill mountains) I was fascinated. We went to the Savoy dance hall the other night my dear you would go mad Ive never in my life seen such a display an enormous floor half dark surrounded by chairs & tables and promenade on one side and the band on the other with a trailing cloud effect behind. Ive never seen such wonderfull dancing they also had an initiation ceremony in which all the men had to crawl under a row of mens legs and be beaton with a stick going through and the women had to be twirled round ten times it most extraordinary spectacle they also had amateur specialities one couple were marvellous a thin marmoset of a creature with cropped crinckled hair and baby shoes and a woolen jumper really its an experience not be missed at any price. The East side Italo Jewish Chinese Spanish and odds and ends district is lovely too a tangle of firescapes washing and just like a Berwick Street thats burst all bounds everything here is more so went to Harlem Opera House to see moonlight and pretzels and arrived in the gallery to find one solid mass of dusky faces there were about 4 white as far as I could see there was a marvelous stage show one woman whos name I of course forget was lovely also "John Henry" (Juan Fernandez) who did a

lovely voodoo number also to a revival meeting
no one did anything very dramatic except an
old negress shouted Lawd aint that so with a
shrill scream at intervals & everyone shook
hands also last night Soph Soph came we went
and saw Pilar Arcas at the Cubo Spanish
theatre down the rd my dear old old Pilar is
heaven 1 inch high and as fat as a fig she has
such a presence and carried on so she sweeps
all before her we saw the Askews yesterday
I feel we are going to have Baldwin trouble
Soph Soph cant bear the sight of her ah we
all have our little crosses to bear Well dear
au revoir write to 1890 7th av.
Yrs Ed

11 *To* WILLIAM CHAPPELL *Madrid, c.1934*
. . . I have just been to the flamenco singing
competition at a place called the Circo Price
realy Ive never seen anything like it I went
in at 6.30 & came out half dead at 10.30 & it
was still going on I left just after a wonderful
old cook had shouted for an hour realy she
must have been at least 60 with grey hair.
She was wonderful there was also a marvellous

little boy aged about 10 in a red jersey
accompanied by my new favourite Nino de
Sanbucar a guitar player to bring tears to your
eyes its so beautiful. his *feet* Ive never seen
anything like in my life such elegance tiny
& the most wonderful shoes . . .

12 *To* WILLIAM CHAPPELL *Springfield,
October 1944*
We had a lovely first night in the Gorbals.
Youve no conception how I enjoyed myself,
it was wonderful. Everybody was disgusted.
They made a very good job of it I must say . . .
I saw Sophia & Beryl de Zouter in an astrak-
han toque—she was outraged, & still more
so when I said I thought the razors in the
slashing no. ought to have been made of
diamonte to *twinkle* sharper!! after 4 double
gins & a few more squeezed in a basket chair in
the lounge with enormous bottoms squeezed
in our faces. no one wants to sit down—they
all want to be *seen*, said Mrse. Pease—with a
a leapard skin hat. (the same) crooked over one
eye. I never saw any notices of course, but
some of the Sunday papers got quite hysterical.

this is dress it in the I hear Reitlingers party was rather on the dull side so Billy said every body seems to there or even dressed Beau Ethel Bert as Topsy & white was Topsy & Eva he needed make up. My would be risen Beranger appeared as

exactly. like the caused quite a furore shaftsbury jolly & you can think have been far as I can see Mr Jowett as a victoria a Mr & Mrs white went Eva Mrs and Mr Weavas scarcely any dear the 4th seats to 12/6" if André de a queen of the Blvds" anyway

I want to see it Clover says its on with out of the mists which is lovely such a drama it has Werner Fuetter in it

face in the new close up that Greta Ebrman & Suzi Veron (P.To

Anyway the Spectator gave me a good notice. Ill try & send some. Its a gripping melodrama realy. of course, I couldnt take my eyes off it. all it wants is a fall of snow. but Ive no doubt youll be hearing about it!! The music was very good.

13 *To* WILLIAM CHAPPELL *Springfield c. 1945*
. . . The Grigson arrived yesterday. I must say its a very enjoyable interesting little compilation Thomas Chatterton's extracts are realy fruity. There was also a peice by squire Waterton of Waterton Hall. a Birdman, he was very eccentric and always dressed in school boys knickers & a neat cap so he could shin up a palm to look at a vultures egg. The peice quoted is about vampires—realy a triumph Ive been trying to make Humphrey read Waterton being a birdman too. Fred I hear has a London job so everything is fine I suppose. Yesterday was an extraordinary day so warm & summer like, everything is coming out. I went to the top of the garden & realy the view was a magic scene without a breath and wonderful pale green mist on the willow plantation & a sort of mauve shadow. very "romantic" indeed it was.

14 *To* WILLIAM CHAPPELL *Springfield, c. 1945*
. . . Im beginning to care about nothing at all exept enough to eat & laying down. Painting of course is a kind of drug. The very sight of peoples faces sickens me Ive got no pity it realy is terrible sometimes Ime quite frightened at myself I think such awful things I get in such paroxysms of impotent venom I feel it must poison the atmosphere. I see that Hitchcock film was actually taken in a Californian town to save set & money. my god why dont they always save sets & money it would get a breath of old world silent natural surroundings instead of made sets which look made however good they are . . .

Catalogue

NOTE

The drawings and paintings described as in watercolour are on paper. The latter medium frequently includes pencil lines and gouache in addition to clear watercolour.

Dimensions are given in inches and (in brackets) centimetres, with height preceding width.

1 SPRINGFIELD GARDEN, 1922
Watercolour, 23 × 17 (58.5 × 43)
The Hon. Mrs Colin Ritchie

2 THE ANNUNCIATION, c.1923
Watercolour, 18½ × 24½ (47 × 62)
The Hon. Mrs Colin Ritchie

3 TARTS, 1923
Pen and ink, 15 × 11 (38 × 28)
Mr and Mrs Nicholas Jones

4 MARKET DAY, 1926
Watercolour, 21¾ × 14¾ (55 × 37.5)
Private Collection

5 FIESTA, 1926
Watercolour, 17 × 15 (43 × 38)
S. Martin Summers

6 THE TERRACE, 1927
Watercolour, 23½ × 18½ (60 × 47)
The Lord and Lady Walston

7 CEDAR AT SPRINGFIELD, c.1927
Oil, 25 × 20 (63.5 × 51)
William Chappell

8 LES BOYS, 1928
Pen and ink, 22 × 15 (56 × 38)
John Schlesinger

9 FOLIES DE BELLE VILLE, 1928
Watercolour, 25 × 20 (63.5 × 51)
Private Collection

10 THE TEA SHOP, 1929
Watercolour, 26 × 18¾ (66 × 47.5)
J. F. Cullis

11 LE BAL, 1928
Watercolour, 25¾ × 18½ (65.5 × 47)
Private Collection

12 MARRIAGE A LA MODE, 1928
Watercolour, 24½ × 20 (62 × 41)
Barbara Ker-Seymer

13 SHOW GIRLS, 1929
Pencil, 30 × 14¾ (76 × 54.5)
Mrs Desmond L. Corcoran

14 THE TWO SISTERS, 1929
Oil, 23½ × 19½ (60 × 49.5)
Private Collection

15 THE BALCONY, TOULON, 1929
Oil, 20 × 16 (51 × 41)
Private Collection

16 THE RAILWAY GANG, 1929
Oil, 27 × 20 (68.5 × 51)
Mrs Gerald MacCarthy

17 THE KITE, 1929
Oil, 21¾ × 30 (55 × 76)
Hamet Gallery

18 COMPOSITION, 1929
Collage, 15 × 11 (38 × 28)
Lefevre Gallery

19 THE CAFE, c.1929
Watercolour, 21½ × 29½ (55 × 75)
Penelope Allen

20 DANDIES, 1930
Pen and ink, 13 × 10 (33 × 25.5)
Sir John Rothenstein, CBE

21 EARLY NIGHT, 1930
Pen and ink/wash, 19⅜ × 15 (49 × 38)
Private Collection

22 THREE SAILORS AT A BAR, 1930
Watercolour, 26½ × 19 (67.3 × 48.2)
Private Collection

23 THE SNACK BAR, 1930
Oil, 30 × 21¾ (76 × 55)
Helen Grigg

24 THE DUENNA, 1930
Watercolour, 21⅜ × 14¾ (54.5 × 37.5)
Private Collection

25 SET FOR RIO GRANDE, 1930
Watercolour, 17½ × 29 (44.5 × 73.5)
Lefevre Gallery

26 ROUGH ON RATS, c.1930, with Paul Nash
Collage and pencil, 19¼ × 14½ (49 × 37)
Private Collection

27 COLLAGE, 1930
Collage and watercolour, 20 × 15½ (51 × 39.5)
Barbara Ker-Seymer

28 KEEP YOUR HEAD, c.1930
Collage and pencil, 23½ × 21⅜ (59.5 × 54)
Tate Gallery

29 VENEZ AVEC MOI, c.1930
Collage and pencil, 24 × 19 (61 × 48)
Anthony d'Offay

30 THE HAM, 1931
Oil, 20 × 27 (51 × 68.5)
Barbara Ker-Seymer

31 MINUIT CHANSON, 1931
Watercolour, 21½ × 29 (54.5 × 73.5)
Barbara Ker-Seymer

32 MADAME BUTTERFLY, 1931
Watercolour, 22 × 29¾ (56 × 75.5)
J. F. Cullis

33 JOHN DETH, 1932
Watercolour, 22 × 30 (55.9 × 76.2)
Private Collection

34 THE HOSTESSES, 1932
Watercolour, 23 × 18½ (58.5 × 47)
Private Collection

35 THE DUENNAS, 1932
Watercolour, 21¾ × 17 (55 × 43)
Beatrice Dawson

36 DANCING COWS, 1933
Watercolour, 23⅜ × 18¾ (59.5 × 47.5)
Beatrice Dawson

37 SUPER CINEMA, c.1934
Pen and ink, 19¼ × 15 (49 × 38)
Anthea Pooley

38 THE PARTY, c.1934
Pen and ink, 21 × 17½ (53.5 × 44.5)
Mr and Mrs A. D. Pilcher

39 ON THE SHORE, 1934
Watercolour, 20 × 24⅜ (51 × 62.7)
Sir John Rothenstein, CBE

40 MUSIC HALL, 1934
Watercolour, 22½ × 31 (57 × 79)
Private Collection

41 DANCING SKELETONS, 1934
Watercolour, 31 × 22 (75 × 56)
Tate Gallery

42 BULL FIGHT, c.1934
Watercolour, 22 × 30 (56 × 76)
Private Collection

43 HARLEM, 1934
Watercolour, 31 × 22 (79 × 56)
Tate Gallery

44 FUN FAIR, 1935
Pen and ink, 23½ × 19¼ (59.5 × 49)
Mark A. Vaughan-Lee

45 THE TENEMENT, 1935
Pencil, 23½ × 18¾ (59.5 × 47.5)
Miss M. A. Du Cane

46 EL PASO, 1935
Watercolour, 52½ × 44 (133 × 112)
D. W. E. Eckart

47 MADAME PASTORIA, 1935
Watercolour, 25½ × 17¾ (65 × 45)
Desmond L. Corcoran

48 OYSTER BAR, HARLEM, 1935
Watercolour, 30 × 22 (76 × 56)
Desmond L. Corcoran

49 SAVOY BALLROOM, HARLEM, 1935
Watercolour, 23¾ × 18½ (60 × 47)
Private Collection

50 MAE WEST, 1935
Watercolour, 30 × 22 (76 × 56)
Desmond L. Corcoran

51 COMPOSITION, 1935
Watercolour, 20 × 33½ (51 × 85)
Private Collection

52 THE TORTURERS, 1935
Watercolour, 31 × 22 (79 × 56)
Sir John Rothenstein, CBE

53 HARBOUR WITH BOATS, PLYMOUTH, 1935
Watercolour, $29\frac{1}{2} \times 56\frac{5}{8}$ (75 × 144)
Kuhn, Loeb & Co. International

54 LANDSCAPE NEAR RYE, 1930s
Watercolour, 22 × 31 (56 × 79)
William Chappell

55 THE MENDICANT, 1935
Watercolour, $57\frac{1}{2} \times 41\frac{1}{2}$ (146 × 105)
Private Collection

56 CHILE CON CARNE, c.1935
Watercolour
Private Collection

57 AGONY IN THE GARDEN, 1936
Watercolour, $28\frac{1}{8} \times 42\frac{3}{8}$ (71.5 × 107.5)
Edward Lydall

58 BLUE ROBED FIGURE UNDER A TREE,
 1937
Watercolour, $46 \times 33\frac{1}{2}$ (117 × 85)
The Lord and Lady Walston

59 LANDSCAPE WITH RED WHEELS, 1937
Watercolour, 19 × 24 (48.2 × 61)
Sir Robert Helpmann

60 THE POINTING FINGER, 1937
Watercolour, 27 × 15 (68.5 × 38)
A. F. Roger

61 THE PUPPET, 1937
Watercolour, 40 × 30 (101.5 × 76)
The Lord Killanin

62 THE WAKES, 1937
Watercolour, $40\frac{1}{4} \times 27\frac{1}{2}$ (102 × 70)
Tate Gallery

63 THE WATCHER, 1937
Watercolour, 38 × 24 (96.5 × 61)
Scottish National Gallery of Modern Art

64 TREES, c.1937
Watercolour, 65 × 31 (165.1 × 78.7)
Lefevre Gallery

65 THREE FATES, c.1937
Watercolour, 52 × 44 (132.1 × 111.8)
Lefevre Gallery

66 WAR IN THE SUN, 1938
Watercolour, 42 × 62 (106.5 × 157.5)
The Lord and Lady Walston

67 THE PRISONER OF FATE, 1938
Watercolour, 43 × 31 (109 × 79)
Sir Frederick Gibberd

68 MEXICAN CHURCH, 1938
Watercolour, $51\frac{1}{2} \times 40\frac{3}{8}$ (131 × 102.5)
Tate Gallery

69 CAMOUFLAGE, 1938
Watercolour, $40 \times 28\frac{1}{2}$ (101.5 × 72.5)
Private Collection

70 BEELZEBUB, c.1938
Watercolour, 61 × 44 (155 × 114)
Lefevre Gallery

71 OLD IRON, c.1938
Watercolour, $38\frac{1}{2} \times 51\frac{1}{2}$ (97.8 × 130.8)
Lefevre Gallery

72 BLASTED OAK, 1942
Watercolour, 25 × 29 (63.5 × 73.7)
Arts Council of Great Britain

73 SOLDIERS, 1942
Watercolour, 41½ × 81½ (105.4 × 207.6)
Tate Gallery

74 BIRD WOMEN, 1945
Watercolour, 29¾ × 22 (75.6 × 55.9)
Lefevre Gallery

75 WEST OF IRELAND, 1946
Watercolour, 31 × 44 (78.8 × 111.8)
Lefevre Gallery

76 SCULL IN LANDSCAPE, c.1946
Watercolour, 21¾ × 30 (55.2 × 76.2)
Hamet Gallery

77 BIRDMAN AND POTS IN A LANDSCAPE,
1947
Watercolour, 22 × 30½ (55.9 × 77.5)
Private Collection

78 BIRDMEN AND POTS, 1947
Watercolour, 31½ × 22¾ (80 × 57.8)
Lefevre Gallery

79 RAILWAY VIADUCT, 1947
Watercolour, 31 × 44 (78.8 × 111.8)
Private Collection

80 RYE LANDSCAPE WITH FIGURES, 1947
Watercolour, 27 × 40 (68.6 × 101.6)
Cecil Higgins Art Gallery

81 JUDITH AND HOLOFERNES, 1947
Watercolour, 40⅜ × 52 (102.5 × 132.1)
Mr and Mrs Jean-Jacques Boissier

82 DUBLIN STREET SCENE NO. 2, 1948
Watercolour, 26 × 40 (66 × 101.6)
Lefevre Gallery

83 COSTUME SKETCH FOR DON JUAN, 1948
Watercolour, 20 × 14 (50.8 × 35.5)
Lefevre Gallery

84 IT'S ALL BOILING UP, 1948
Watercolour, 23 × 31 (58.4 × 78.8)
D. W. E. Eckart

85 SET FOR DON QUIXOTE NO. 1, c.1948
Watercolour, 26 × 40 (66 × 101.6)
Lefevre Gallery

86 THE MARKET, 1949
Watercolour, 27 × 40 (68.6 × 101.6)
Ian Dunlop

87 SIMON OF CYRENE, c.1950
Watercolour, 52 × 39½ (132.1 × 100.3)
Desmond L. Corcoran

88 THE MOCKING OF CHRIST, 1952
Gouache on paper, 53¾ × 52 (136.5 × 132.1)
University of Dundee

89 OPENING OF THE HUNTING SEASON, 1952
Watercolour, 29 × 41½ (73.7 × 105.4)
Lefevre Gallery

90 CORONATION OF THE VIRGIN, c.1952
Watercolour, 80 × 52 (203 × 132)
Michael Benthall, CBE

91 SCENE IN HARLEM (SIMPLY HEAVENLY),
c. 1952
Watercolour, 28½ × 42 (72.4 × 106.7)
Lefevre Gallery

92 SKELETON PARTY, c.1952-54
Watercolour, 27½ × 40¼ (69.8 × 102.2)
Tate Gallery

93 STILL LIFE WITH FIGURES, 1953
Watercolour, $21\frac{1}{2} \times 29\frac{1}{2}$ (54.6 × 74.3)
Lefevre Gallery

94 BOTTLES IN A LANDSCAPE, c.1953
Watercolour, $27\frac{1}{4} \times 20$ (69 × 50.7)
Trustees of the British Museum

95 ELEPHANT LADY, 1954
Watercolour, $23 \times 30\frac{1}{2}$ (58.4 × 77.5)
Lefevre Gallery

96 THE FISH WOMEN, 1954
Watercolour, $22 \times 29\frac{3}{4}$ (55.9 × 75.5)
Lefevre Gallery

97 POT WOMEN, 1954
Watercolour, $22 \times 29\frac{3}{4}$ (55.9 × 75.5)
Private Collection

98 ESSO, c.1955
Watercolour, $28\frac{1}{4} \times 41$ (72 × 104)
J. O'Brien

99 STILL LIFE, DISHES AND BOTTLES, 1956
Watercolour, 28×42 (71.1 × 106.7)
Lefevre Gallery

100 LIFE STUDY (SHRUBS, LILIES
AND IRIS), 1957
Watercolour, 42×28 (106.7 × 71.1)
Private Collection

101 OWL AND QUINCES, c.1957
Watercolour, 52×32 (132 × 81.5)
A. F. Roger

102 STILL LIFE, c.1957
Watercolour, 31×45 (78.8 × 114.3)
The Hon. Mrs Colin Ritchie

103 STILL LIFE WITH BASKET, c.1957
Watercolour, $28\frac{5}{16} \times 40\frac{15}{16}$ (72 × 104)
J. G. Aspinall

104 CYCLAMEN, c.1957
Watercolour, $30 \times 22\frac{1}{2}$ (76.2 × 57.1)
Private Collection

105 FLOWERS IN A POT, c. 1957
Watercolour, 54×33 (137.1 × 83.8)
Private Collection

106 CHRYSANTHEMUMS AND ASTERS, c.1958
Watercolour, $52 \times 30\frac{1}{2}$ (132.1 × 77.5)
Mrs Desmond L. Corcoran

107 THE MULBERRY TREE, 1959
Watercolour, 31×53 (78.8 × 134.6)
British Petroleum Company Limited

108 LANDSCAPE WITH BEANS, c.1959
Watercolour, $30\frac{1}{4} \times 53\frac{1}{2}$ (76.9 × 135.9)
Private Collection

109 PUNCH AND JUDY, 1960
Watercolour, $21\frac{1}{2} \times 29\frac{1}{2}$ (54.6 × 74.9)
Lefevre Gallery

110 THE FIRE, 1960
Watercolour, $30\frac{1}{2} \times 53$ (77.5 × 134.6)
Lefevre Gallery

111 THE STRAW MAN, 1963
Watercolour, 31×44 (78.8 × 111.8)
Private Collection

112 CONNEMARA, c.1963
Watercolour, 29×53 (73.7 × 134.6)
Vickers Limited

113 THE ALLOTMENTS, c.1963
Watercolour, 30 × 52½ (76.2 × 133.3)
Sir Antony Hornby

114 RIVER ROTHER, EARLY MORNING, c.1963
Watercolour, 30 × 52½ (76.2 × 133.3)
Mr and Mrs John Deen

115 LOW TIDE NEAR RYE, c.1963
Watercolour, 29¾ × 52½ (75.5 × 133.3)
Joseph Janni

116 WINTER, 1964
Watercolour, 54 × 32 (137.2 × 81.2)
Arts Council of Great Britain

117 THE GOSSIPS, 1964
Watercolour, 30¼ × 26¼ (76.8 × 66.6)
Lefevre Gallery

118 THE BOOZER, c.1964
Watercolour, 31¼ × 18 (79.4 × 45.7)
V. G. White

119 THE MARKET, 1965
Watercolour, 33½ × 39½ (85.1 × 100.3)
J. Walter Thompson Collection (London)

120 FLOWERS, c.1965
Watercolour, 30¾ × 40½ (78.1 × 102.9)
Sir John and Lady MacLeod

121 THE TUNNEL, 1966
Watercolour, 30½ × 51 (77.5 × 129.5)
George Melly

122 BIRDS, 1966
Watercolour, 26½ × 31¼ (67.3 × 79.4)
Lefevre Gallery

123 AFTER THE MARKET CLOSED, c.1966
Watercolour, 52 × 31 (132.1 × 78.8)
Mrs Desmond L. Corcoran

124 ROCKS AND SEAWEED, GALWAY, 1967
Watercolour, 30 × 52½ (76.2 × 133.3)
Conrad Goulden

125 MACHINES QUARRELLING, 1967
Watercolour, 31 × 52½ (78.8 × 133.3)
Lefevre Gallery

126 THE MARKET, 1967
Watercolour, 22¾ × 31 (57.8 × 78.8)
Lefevre Gallery

127 EAST ANGLIA, 1967
Watercolour, 31 × 52½ (78.8 × 133.3)
Private Collection

128 ENGLISH COUNTRYSIDE, c.1967
Watercolour, 31¼ × 52 (79.4 × 132.1)
Private Collection

129 YORKSHIRE LANDSCAPE, c.1967
Watercolour, 31 × 52½ (78.8 × 133.3)
Private Collection

130 VIEW AT FLORENCE, c.1967
Watercolour, 32 × 52 (81.2 × 132.1)
A. F. Roger

131 PEARS, c.1967
Watercolour, 22¼ × 31 (56.5 × 78.8)
Mrs Gordon Binnie

132 FLOWERS IN A VASE, c.1967
Watercolour, 21½ × 12½ (54.6 × 31.7)
Mr and Mrs Cecil Bernstein

133 FROZEN LANDSCAPE, c.1969
Watercolour, 31 × 52½ (78.8 × 133.3)
Dame Cicily Andrews, DBE

134 WYE VALLEY NO. 1, c.1969
Watercolour, 31¼ × 52¼ (79.4 × 132.7)
Private Collection

135 SALOME, HEROD AND HERODIAS AND
ST. JOHN THE BAPTIST'S HEAD, c.1969
Watercolour, 31 × 33 (78.8 × 84)
The Rt Hon. Lord and Lady Craigmyle

136 CORNISH CLAY MINES, 1969-70
Watercolour, 40 × 53 (101.6 × 134.6)
Max Ker-Seymer

137 A VIEW OF ROCHESTER, 1970
Watercolour, 31 × 52½ (78.8 × 133.3)
Lefevre Gallery

138 THE GIANT CABBAGES, 1970
Watercolour, 31 × 52½ (78.8 × 133.3)
Lefevre Gallery

139 CRAB COCKTAIL, 1971
Watercolour, 31 × 52½ (78.8 × 133.3)
Lefevre Gallery

140 A VIEW AT CORNWALL, 1971
Watercolour, 31 × 52½ (78.8 × 133.3)
Private Collection

141 IN'CUBI AND SUCC'UBI, 1971
Watercolour, 32¾ × 55 (83.2 × 139.8)
Douglas Villiers

142 WHIRLING DERVISHES, 1971
Watercolour, 30¾ × 53 (78.1 × 134.6)
Private Collection

143 AN ENGLISH COUNTRY SCENE, c.1971
Watercolour, 31 × 52½ (78.8 × 133.3)
Private Collection